Lost *but* Found

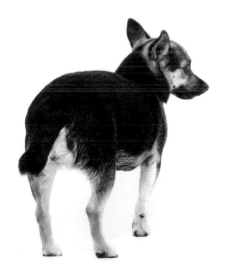

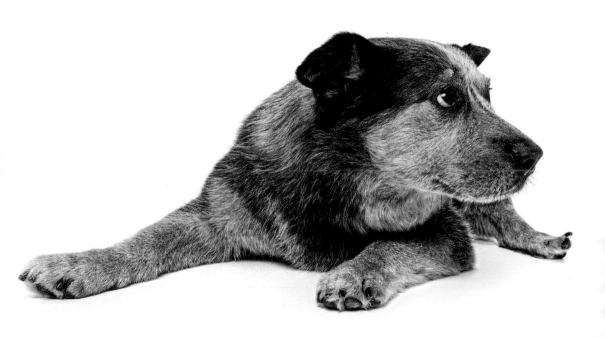

RESCUE DOGS AND THEIR STORIES OF ADOPTION

Lost *but* Found

PETER SHARP

AND

SYDNEY DOGS & CATS HOME

Pan Macmillan Australia

First published 2019 in Macmillan by Pan Macmillan Australia Pty Ltd
1 Market Street, Sydney, New South Wales, Australia, 2000

Cataloguing-in-Publication entry is available
from the National Library of Australia
http://catalogue.nla.gov.au

Design by Big Cat Design
Printed by Hang Tai Printing Co. Ltd.

This book is dedicated to all of the staff and volunteers who work at Sydney Dogs & Cats Home and, most importantly, to the animals who have inspired this project.

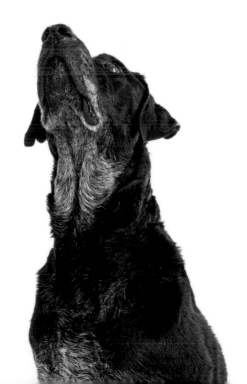

INTRODUCTION

Sydney Dogs & Cats Home is unique in its ability and commitment to find that 'one in a million' owner for rescue animals in their care, as well as that 'one in a million' pet for people looking to adopt.

Filled with photography by award-winning pet photographer Peter Sharp, this book is more than just a compilation of beautiful images. It is an extension of Peter's volunteer work with the Home and his personal mission of caring and capturing the stories of the often neglected or sick animals he has photographed.

What had happened to them before? What happens to them next? Did these lost souls become found? Who found them? Had these people been lost too?

These forty stories from the Home reveal how the dogs came to be lost, how and why they were in the shelter, and the love and care they received. They also show the journey of the dogs finding their new homes, and what life is now like for both dog and owner. Some of the tales are confronting, some devastatingly sad. Other stories are uplifting and joyful, showing the best of dog- and human-kind.

The touching and inspiring accounts in this book have been handpicked by Peter Sharp and the staff and volunteers of the Home. It is just a tiny sampling of the dogs who have come through the shelter and positively changed people's lives forever.

You'll meet little Squid, the adventurous Fox Terrier-cross with his own Instagram account; Chance, a gentle, older Staffy-cross who proves it's never too late for a second chance; Mimi, whose boundless love and affection helped her new family through some rough times; and Bluey,

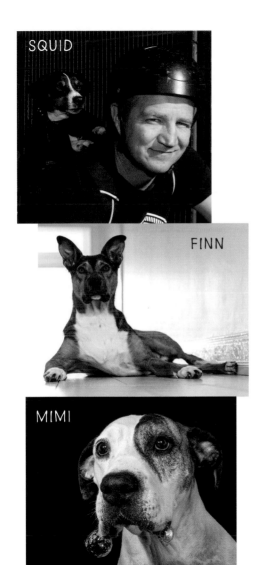

SQUID

FINN

MIMI

a beloved Cattle Dog whose golden years with his adopted family were the best in his life.

Above all, *Lost but Found* is a book about difficult and inspiring individual journeys, and a dedicated and enthusiastic community that never gives up hope.

Within these pages, you'll also find information on key tips to keep in mind when adopting a pet as well as the importance of microchipping, desexing and looking after your furry friend so they don't end up in an animal shelter.

Everyone, human and dog, has a story to tell. In the ones you're about to read, you will discover the philosophy of the Home, the significance of its mission and its core ethos that every creature is worthy of dignity and love.

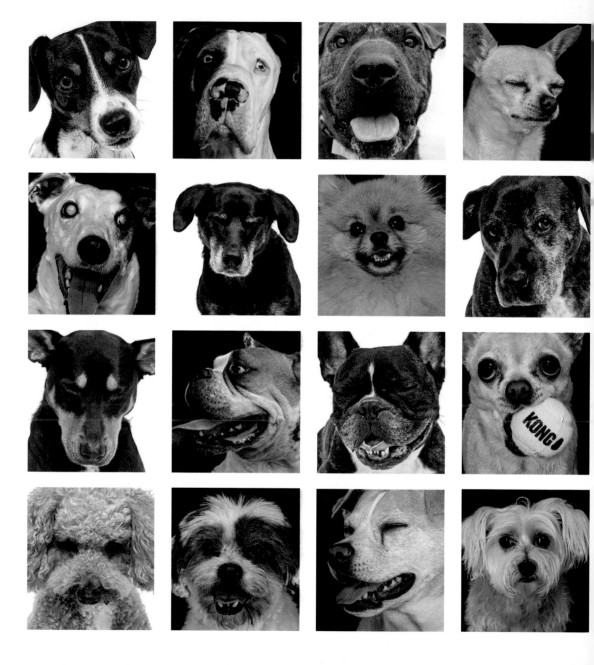

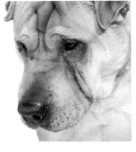

THE DOGS

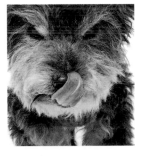

CHANCE

STAFFY-CROSS | 10 YEARS

EVERY DOG DESERVES A SECOND CHANCE.

Arlo, as she was previously known, originally arrived at the Home after she'd slipped away from her owner, who was struggling to find suitable housing for them.

Ultimately unable to find adequate accommodation, Arlo's owner was no longer able to look after her so surrendered her to the Home.

At nine and a half years old, Arlo was suffering from a degenerative joint disease in her left elbow that required ongoing pain management and vet checks.

A very loyal and sweet girl, she found a special place in the hearts of everyone at the Home and enjoyed resting in a warm spot with the staff or going for slow walks with the volunteers.

Although she responded well to humans, Arlo found it hard to interact with other dogs in the Home and seemed quite sad and a bit lonely.

If only it was known that just a few weeks later, a very special family would come to the Home, looking for an older dog to come into their lives.

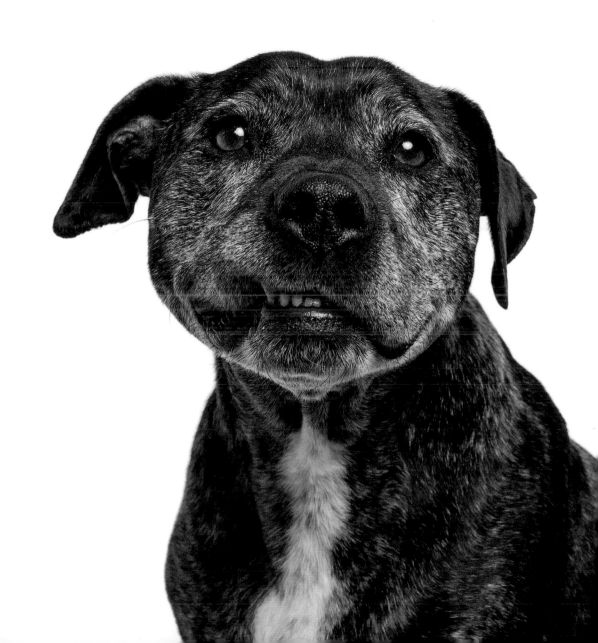

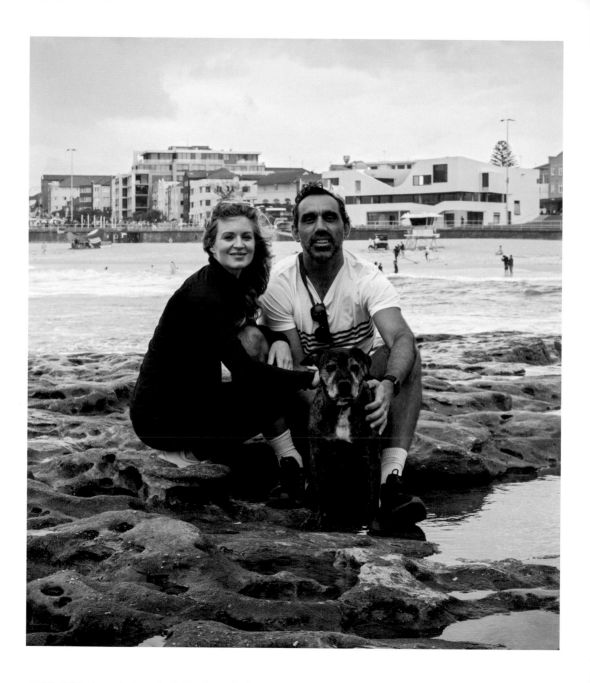

FOUND It was always our plan to give an older dog a loving, caring home for their golden years. At the Home, we met lots of loud, boisterous dogs but couldn't find anyone to mesh with our family and lifestyle. As luck would have it, a member of staff took us over to meet this timid girl. She was so shy that we hadn't even **seen** her curled up at the back of her kennel, but as soon as we saw her grey face and sad eyes, we knew. Here was our chance to have a new member of the family, and her chance to have a forever home. Of course we had to call her Chance!

Chance needs a lot of careful attention for her joint care, but she honestly acts like a puppy a lot of the time, not realising her limits as a ten-year-old. She sometimes tries to jump onto our bed, but halfway up, fails and falls off. Then she tries again. She's so determined, and stronger than she looks. When Chance was over at her aunty's, a storm came through and no one was home.

She got through a baby gate, a locked door and a closed outdoor gate before crashing the neighbour's birthday barbecue. We're still not sure how our sweet, cautious girl managed it.

Chance has enhanced every facet of our lives. We are home more to spend quality time together as a family and love how ecstatic she is when we come home. We make all our plans with her in mind and it's a bit of a nuisance that grocery stores and aeroplanes don't allow dogs. She's a member of the family, stubborn, loyal, lovable and ours.

– *Adam and Natalie Goodes*

AN INTERVIEW WITH CHANCE

What would you say to potential new guests of Sydney Dogs & Cats Home?

Don't be scared. There are some really friendly staff and volunteers.

What is your favourite toy and why?

An elephant called Jumbo. I like to grab onto his trunk and have a little wrestle, then I'm pooped!

What is the funniest thing you have ever done?

I once farted for a whole minute straight. Halfway through, I looked up because I was wondering what that funny noise was and where it was coming from.

What is the naughtiest thing you have ever done?

I have lots of friends wanting to take me for walks, so we go out but then when I'm on the footpath outside my house I lay down in protest and won't move. They haven't learnt yet, that I only go for walks with Mum and Dad!

If you could be anything or anyone in the world who or what would you be and why?

Probably still myself because I've got it pretty good right now. I'm so loved and cared for and I have so much love to give.

Who is your favourite family member and why?

Whoever feeds me!

CHARLIE

LOST LABRADOODLE | 10 MONTHS

SOME ANIMALS NEED A LITTLE MORE TIME AND ASSISTANCE
TO FIND THEIR FOREVER HOMES, BUT PATIENCE AND
PERSEVERANCE WILL ALWAYS BE REWARDED.

Charlie was less than a year old when he arrived at the Home.

He had a condition called Pica, which is a compulsion to chew on non-food items, and he had a vigour and verve that was way beyond normal puppy behaviour. Over the next six months, Charlie was rehomed and returned twice by families who couldn't quite manage him.

Charlie needed extra assistance to overcome his behavioural and anxiety issues, so staff member Sue decided to make Charlie her first foster dog. While he was in her care, Sue worked diligently with him so that he would stop eating things he shouldn't and she taught him to redirect his energy.

For more than two months, she trained him to be a much calmer dog, who would not bark or run around in circles when there were visitors, without breaking his excitable spirit.

Charlie's rehabilitation involved a structured routine such as daily exercise, and reinforcement of acceptable behaviours to help build his manners. Along the way there were many hiccups, including a

Did you have a favourite staff member or volunteer?

My aunty Sue, who fostered me for a couple of months. She had loads of patience and taught me some manners.

How did you choose your new home?

They already had a Labradoodle named Chad, plus kangaroos, cows, chooks and ducks and 50 acres! Oh, and these two nice humans who seemed to get me.

What would you say to potential new guests of Sydney Dogs & Cats Home?

They'll look after you and then find you a great place to call home.

Charlie is so full of personality and is always making us laugh and smile. We have cattle and Charlie thinks they are just big dogs and spends a lot of time taunting and barking at them. He just can't understand why they don't want to play!

Chad and Charlie get along wonderfully. Chad gives Charlie a lot of emotional stability, and helps him burn off all that excessive energy, and Charlie has brought back the puppy in Chad. They'll play together for hours, especially tug-of-war, outside with the chooks.

Charlie loves meeting new people and other dogs as well. He loves going on outings, especially to the dog beach, and even going to the vet. Jumping up on people when he's excited is still a problem, but he soon has them wrapped around his paw.

We know he had some false starts, but we think he was hanging out for us and Chad, just waiting to come home.

– Michelle

memorable emergency trip to the vet after Charlie swallowed a dressing gown cord! However, all the hard work and time that Sue, Charlie and the Home invested had paid off.

FOUND We were looking for a companion for our four-year-old Labradoodle, Chad. Charlie was our perfect match, because we'd already had experience with behaviourally challenged dogs and Charlie needed a mate to play with. We have a 50-acre property that the two buddies have made their own playground.

BLUEY

LOST | CATTLE DOG | 15 YEARS

AGE IS JUST A NUMBER, AS PROVEN BY THIS
HANDSOME OLDER GENTLEMAN.

Bluey was brought into the Home as a stray. Although he was microchipped, the details were not up-to-date, so it took some extra sleuthing to find his owner. Unfortunately, the owner made the heartbreaking decision to give Bluey up due to financial hardship, even with the offer of assistance of care and food from the Home.

The team set about finding Bluey a loving home where he could enjoy his twilight years. Given his advanced age and arthritic condition, they were concerned it might take some time to find that one in a million person who would appreciate this special dog.

Although the entire team had fallen hard for this dear old soul, they knew it was best for Bluey to be placed into foster care.

Luckily, Amy and Mish were ready to provide Bluey with a temporary home. With their full-time work schedules, they didn't feel they could adopt, but as Amy worked week on/week off, they registered as foster carers to give dogs a break from the Home. They'd previously fostered a high-energy young dog but realised their lifestyle would be better suited to an older, less active dog, so Amy and Mish took Bluey into foster care.

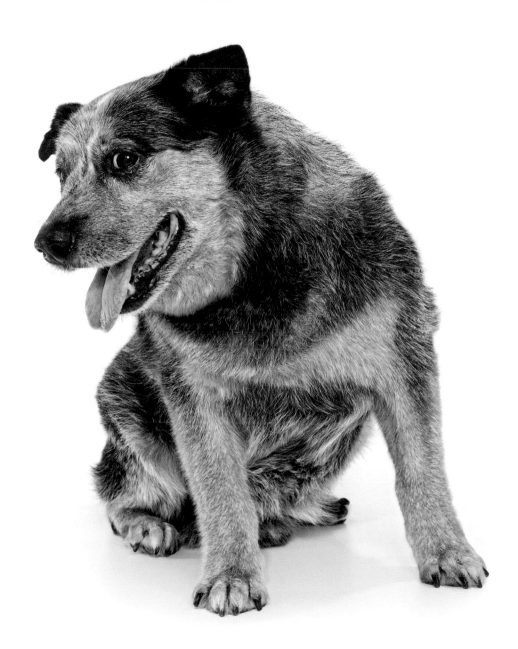

Less than a week later, Mish and Amy were enchanted with Bluey and the feeling was mutual. They realised they could give Bluey the home, comfort and support he needed in his twilight years, and they made the decision to adopt him.

FOUND We're proud to be a 'failed' foster family. When we picked Bluey up, we were mindful of his arthritis, so after a slow, steady stroll to our car, we were prepared to help this old guy get up. Then he just leapt in! He made himself very comfortable in the front passenger seat. Bluey knew he was home, and soon, we did too.

Bluey is sweet and affectionate but can be a little melodramatic. Whenever he's done putting up with all our young-person nonsense, he does a very dramatic flop down to sleep. The first time it happened, we thought he'd hurt himself but now we know he's just bored with us and ready for bed. He'll be lying there watching us and then . . . flop!

Bluey is very popular in our neighbourhood, and people will often shout, 'Hi Bluey' as they walk past our house. We can't even catch a glimpse of these people, but they all seem to know him! Everyone who meets him stops to say hi, so we've made lots of new friends through him too. He's very social and his mobility has improved a lot. He's gone from only taking very short 5–10-minute walks to playing and running around at the beach for 1–2 hours.

We both hurry home because we know we have our little wombat waiting to greet us. His big goofy grin and his helicopter tail are too good to miss.
– Amy

Sadly for everyone who loved Bluey, he has now passed away. His family were home and were able to give him one last cuddle. His short time with his final family was the happiest time of their lives.

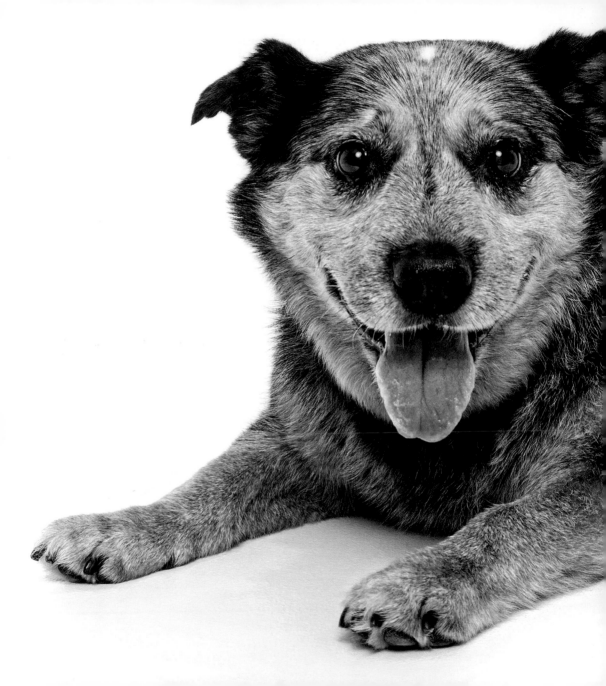

AN INTERVIEW WITH BLUEY

What was your favourite thing to do while staying at Sydney Dogs & Cats Home?

Sleeping and farting in Reception. I got to stay in Reception because I'm so handsome and I became the face of the Home in my short time there.

How did you rate the cuisine?

A solid 10/10 from me, particularly when you get treats from the volunteers . . . then it was 11/10!

What did you think of the staff and the volunteers?

I think the staff and the volunteers are amazing. It's hard work that they do but in return they get to meet fine old fellas like me.

What would you say to someone who was considering adopting?

Adoption gives us a second chance at life. Don't focus on breed, gender, colour or age, focus on finding a dog who you will love and who fits you. If you're lucky like me and my family, you'll all be happier for it.

Any final thoughts?

It's never too late to be loved or to learn something new. I'm 105 and I've found my forever home – and I recently learned to play catch!

FINN

KELPIE-CROSS | 2 YEARS

HIS PAST REMAINS A MYSTERY, BUT IT'S THE PRESENT AND FUTURE THAT COUNT.

Finn was picked up as a stray and brought into the Home. He was microchipped but there was no contact listed on the chip, so the team set off sleuthing to find his owner.

The Home contacted the microchip manufacturer to find out which organisation had purchased the microchip. Unfortunately, when they contacted that organisation, it had no record of the chip on its database. The team then contacted eight vet practices in the area where Finn was found. Sadly, none had a record with Finn's microchip number. Unable to find an owner and with no one coming forward, Finn was transferred into the Home's custody.

It took a bit longer to find Finn a home. Caring for an active Kelpie-cross is a big commitment! However, after spending twenty weeks in the Home's care, Finn found a wonderful new home.

FOUND Finn chose us, and we are so glad he did.

We went to the Home to meet some other pups we'd seen on the website. As we were sitting outside trying to make a decision between three other dogs that we'd met, Finn

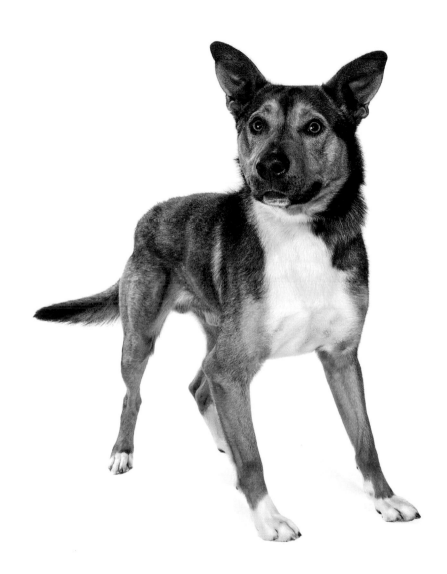

walked past with a volunteer and jumped up on us, giving us big licks and nuzzling in for cuddles. It was pretty much a done deal after that.

Now, we can't really remember life without Finn. He's the biggest, warmest, most loving presence. Our house is a lot messier – like when

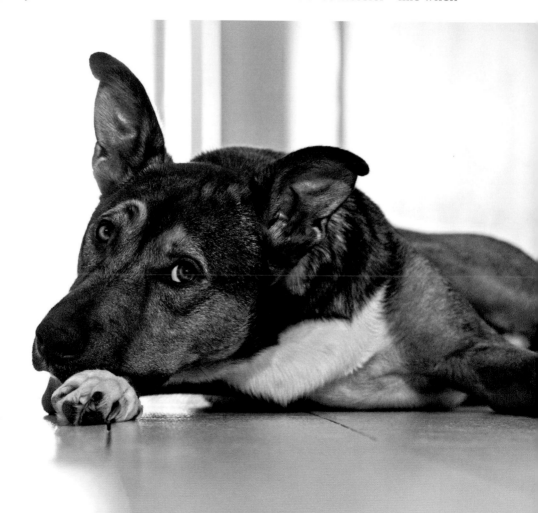

he decides to 'sort' through the contents of our bin and leave everything unchewable all over our kitchen floor – but it's so worth it.

Finn is actually the dopiest dog! It's the funniest thing when he sees his own reflection in our back door and thinks it's another dog. He always runs up all excited, barking and wagging his tail, and won't stop sniffing there for hours. He never seems to wonder where the mystery dog disappears to.

He can't be trusted around food. One morning after a long night shift I got home at 9 am and made myself breakfast, and Finn just decided to take my toast off my plate. He's also a chewer – loves gnawing on things, once including my very expensive retainers. It cost a fortune to replace but he seemed unrepentant.

He loves Dad the most for playtime and wrestling, and he loves Mum the most for cuddles and naps. He's just got a lot of love to give and he's happy to share it. Adopting Finn has changed our lives. We love him so much. Being his owners is the most fulfilling thing we've ever done.

– *Rachel*

HANK

GREAT DANE–BULL MASTIFF | 3 YEARS

THE DOG FORMERLY KNOWN AS PRINCE.

Brought in by the council rangers, this dog was christened Prince. A gentle giant, Prince was microchipped but attempts to contact his owner either went unanswered, or possibly failed because of incorrect details. A three-year-old Great Dane–Bull Mastiff, he was dangerously underweight and as soon as he arrived, the team developed and implemented a strict feeding regime – five cups of dry food with wet, distributed over three to four meals a day – to help this boy gain weight.

Due to his deep chest and his breed, Prince was also in danger of suffering from bloat, which is where the stomach twists and fills with gas, which will result in death if not treated immediately. To combat this Prince was rested an hour before and after eating each meal. This worked a treat and Prince gradually gained weight without complications.

Over the following 40 days, Prince slowly recovered his health. A bit of a cheeky fella, he could never appreciate his own size and loved to romp about, clearly believing himself to be a lapdog.

He was quite content to wait, because someone was coming to rescue this handsome prince.

FOUND The dog formerly known as Prince is now called Hank.

We started to look online for a family pet and came across Hank on the Home's website and we immediately fell in love. It was a little bit like Doggie Tinder, and it was a definite swipe right for us!

Hank brings so much love and joy to our family. He greets each of us with not just a tail wag, but a whole-body wag! He is an incredibly social dog. He loves going to the leash-free park, greeting every dog as they arrive and every owner too. He insists on leaning in for an ear rub and back scratch.

It's hilarious that he really has no idea that he's a large dog. He can clear a coffee table with a flick of his whip-like tail. He is constantly trying to squeeze through small spaces and will regularly get stuck midway through the sliding door and have to back out, or plonk his big body onto your lap for cuddles.

It took me a little while to figure out that no food should be left on the kitchen bench with Hank around. When Hank first joined our family, he would steal whole loaves of bread, leaving only the plastic bag as evidence.

My husband would say that the naughtiest thing he does is climb up on the couch or my son's bed, but the rest of us secretly love it. Hank obviously believes he's being so stealthy that no one will notice. Sometimes he leaves his two back legs touching the floor, so he's technically not on the couch!

He interacts with each family member differently; he snuggles with me on the couch, presents his toys to my sons and husband when they return home from school or work for a tug-of-war game, and generally follows each of us around the house until he settles on who he'd like to spend time with. We all hope it's us.

– *Stephanie*

ZEEK

LOST ROTTWEILER | 10 YEARS

EVEN OLD DOGS CAN FIND THEIR INNER PUPPY.

When Zeek first came into the Home, he was one of the worst cases of neglect they had ever seen. The first thing they noticed was an orange-sized growth, which the team feared was cancerous but turned out to be a large necrotic growth that, due to his poor skin health, had ulcerated and was hanging painfully from his chest.

He was sped through a consult with the vet team and they found he was severely arthritic and his body was covered with large callouses, possibly caused by Zeek spending most of his days on concrete. He was in a lot of pain.

With no owner in sight and in deteriorating health, it was clear that Zeek was not long for this world. His life expectancy at the time was a few months at best. So the Home set to work to ensure that whatever time Zeek had left would be the best it could possibly be.

He bravely endured surgery to remove his pendulous tumour and a pain management plan for his arthritis was developed. This sweet old dog would quickly become a favourite amongst the team and despite his large size and the small office space, there were absolutely no

objections to having Zeek as the daily office dog.

The search started for a warm palliative care placement – preferably a place with a very soft and comfortable bed. It turned out that a loving home was closer than we thought.

FOUND When Zeek first came into the Home, he was in a terrible state and he was hard to read. He didn't like everybody and was easily scared by most things. When he spent time in the office with our team, we formed an instant strong bond.

He would whine whenever I had to leave the room and kept it up until I came back. If I came close, he would paw at me for more love and attention. I was absolutely smitten and worked hard with the team on his medical issues with a view to finding him the perfect home. A senior, arthritic, 50-kg boy with fear-based behavioural issues was extremely hard to rehome. I even went on a live national TV weather cross in the hope of finding interested adopters! Sadly, we had no calls.

It was at this point that I chose to be Zeek's palliative foster carer and give him the very best ending to his life. I nervously and very carefully introduced Zeek to my cat, Libby. To my amazement, Zeek adored her and she, in typical cat fashion, tolerated him.

I was getting myself ready for a short stay and a challenging end to his life. When you foster a senior palliative care dog, you tend to prepare yourself for the worst. What was supposed to be approximately a three-month foster has turned into a full adoption. Zeek has been with us for well over a year now.

This is the first dog I have ever had in my care that has gotten younger the longer I have had him. It's been such a beautiful thing to watch his health and behaviour improve so dramatically. He's evolved to have the outlook and nature of a giant puppy dog, bouncing around and jumping up.

Zeek has changed my life immensely. It can be really hard working in animal welfare at times, and having Zeek in my life has been a constant reminder of how important life is, how beautiful an animal's life can be, and the joy they can bring to their new family, regardless of what horrible things may have happened in their past.

– Stuart

How did you end up at Sydney Dogs & Cats Home?

I am pretty sure I spent my whole life living on concrete and tied up to something. I was really frightened when I was tied up and developed a deep fear of other dogs, tradespeople and bicycles. One day, I chewed through my rope and escaped where I was tied up. I must have wandered alone for a long time. A council ranger caught me and took me to a place filled with other animals, and it was really scary. After they introduced me to a vet and a lot of people trying to help me, I was put in a kennel, but it reminded me of where I was in the first place and all the other dogs made me panicky. I was brought into an office where a team of people worked and no other dogs were around. Everyone gave me pats and cared for me. For the first time since I could remember, I wasn't scared and alone.

What was your favourite thing to do while staying at Sydney Dogs & Cats Home?

When they patted me and scratched my ears and belly, it felt so good. If someone came close to me or tried to stop patting me, I would use my paw to tell them I was making up for lost time and needed more love all the time. I think I must have pawed them all so much. When I found a really special human, I would leave my paw on them so I would know if they tried to leave. Thankfully I never went very long without being loved.

When has there been enough pats, tummy tickles, hugs and kisses?

THERE WILL NEVER BE ENOUGH!!

How did you choose your new home?

I decided I would go home with my favourite human. I went to his home for a while to get some rest until my forever home became available or until everything just hurt too much to continue. Very quickly, we both realised this was my fur-ever home and with all the love and care everyone had shown me, I got healthier and hardly ever felt all that pain anymore. I was home and finally part of a family.

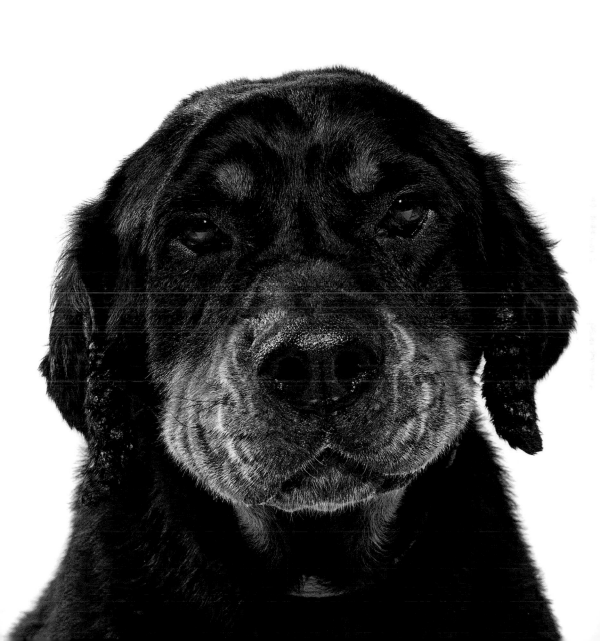

HENRY

LOST FRENCH BULLDOG | 5 YEARS

IF AT FIRST YOU DON'T FIND THE PERFECT HOME, YOU HAVE TO TRY AND TRY AGAIN.

Henry's owner made the impossible decision to surrender Henry into the care of the Home. A beloved pet, his owner was struggling to take care of him and provide Henry with the quality of life he deserves.

During his medical assessment, the Home's vet discovered that Henry was suffering from a range of medical issues, including a skin condition, anxiety and coprophagia (a form of Pica where he ate his own faeces), but the most severe problem was his inability to breathe freely.

This handsome boy has an airway condition that often affects brachycephalic dogs. Henry was having breathing difficulties and the knock-on effects included chronic discomfort and respiratory distress. Surgery was the only viable treatment and without it, Henry's outlook was grim, and possibly even life-threatening.

The examination also revealed that Henry has a heart murmur, which required medication, and that his skin problems were a result of allergies, which made his skin very itchy and irritated, and can be a sign of other underlying health issues. If left untreated, the allergies could

have led to infections. To determine the allergy trigger, the team put him on a food trial, which thankfully helped resolve Henry's skin issues.

When he was feeling better, Henry ruled the roost at the Home. He could always be found in the manager's office and could be very naughty.

Henry was rehomed but unfortunately it didn't work out so he was returned to the Home. Everyone was charmed by him, but it takes a special someone to care for a dog with a few health issues and a lot of personality.

FOUND Our black pug, Pugsley, has enjoyed a peaceful life, but he's never quite been the fully slobbering, brute of a dog we had expected. So we have always been on the lookout for a big-hearted bulldog friend for him (and us!). Bulldogs are hard to find, and we were chasing many opportunities before they all fell through – including some lovable beasts rehomed by the Home. Then came Henry on their website! We initially missed out on him too but he didn't get on well at his first new

AN INTERVIEW WITH HENRY

What was your favourite thing to do while staying at Sydney Dogs & Cats Home?

I ruled the roost there. I was always in the manager's office – quite clearly because that's where I deserved to be, not because I was in trouble a lot. Everyone knew my name and it was always said with an eye roll . . .

How did you choose your new home?

I tried a couple of places before I got this one . . . but they weren't to my liking. Then I met this black pug and he took me to his place. Initially he was friendly, but then I realised he was just a grumpy old man and I was going to have to do all the work. So I turned on the charm and did all the tricks I knew to make sure I became the boss here too.

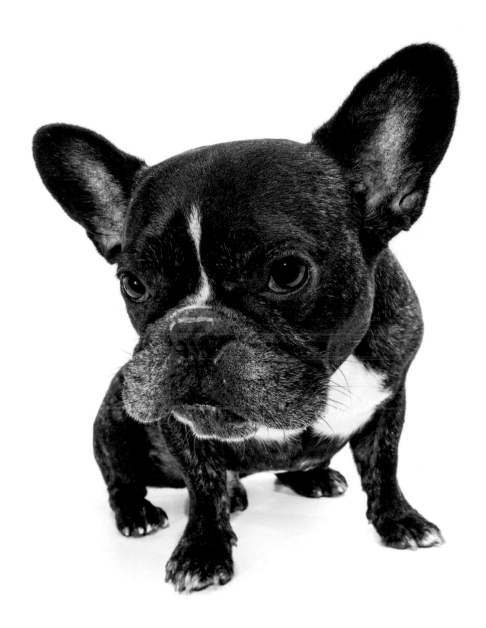

home, so he was returned and we got a second chance.

We adore Henry and we wouldn't want anything else than to have him in our family . . . but wow is he naughty! He regularly steals things that don't belong to him. Many a time he's been chased out of the bathroom with the toilet brush in mouth, and he's become bolder over the months.

Once upon a time, the coffee table was absolutely out of bounds. Now it seems to be a favourite spot for stealing things, such as remote controls and food. Last month, he helped himself to a tub of margarine, licking the container dry before he was caught. Luckily there wasn't much in there, but the insane mess the next few days was . . . not good.

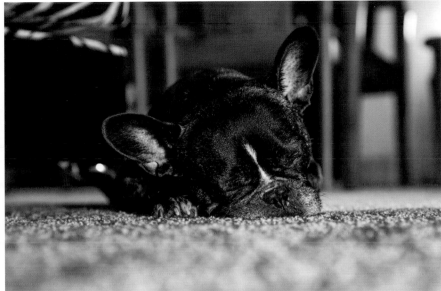

As much as we adore him, he's not the smartest pup in the kennel.

Henry has made life quite different in our home. I can't say we didn't know he had some troubles and I guess that is part of giving a dog a new life – the risk comes with hard work. He desperately needs all of your attention at all times and can be so clumsy and car-chasingly silly. He has an overbearing obsession with Pugsley that can make him very anxious, which manifests in interesting ways. (The grumpy-old-man pug is less than enthused.) We have baby gates, soiled carpet, and matching arm bites, but we also have the most affectionate canine ever. And boy does he give the best cuddles.

– *Luke*

MIMI

STAFFY-CROSS | 5 YEARS

MIMI HAD TO GROW UP FAST BUT NOW SHE GETS
TO ENJOY THE PUPPY LIFE.

Mimosa was picked up as a stray with no microchip or any other form of identification. A routine vet check revealed that this lovely girl had already birthed multiple litters of puppies and was now suffering from heartworm disease. She also had several skin tags that were a worry as they were potentially pre-cancerous. The team de-sexed Mimosa and removed the skin tags and sent them off for testing, and then began treatment for her heartworm.

Mimosa was a big girl, weighing in at 33 kgs, which a lot of people could find intimidating, but she had the sweetest temperament and a heart of gold.

Unfortunately, she could also be very timid and highly anxious so she needed a lot of extra love, and she became a favourite amongst the shelter team. Once she got to know you, she was a big snuggle bug with a lovely disposition. It was just going to take the right person to adopt her to help her overcome her nerves and build her confidence. Thankfully, that perfect person did come along.

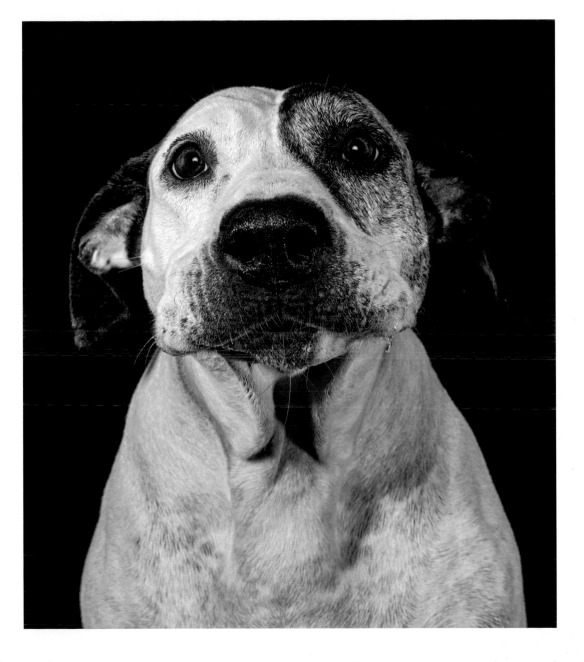

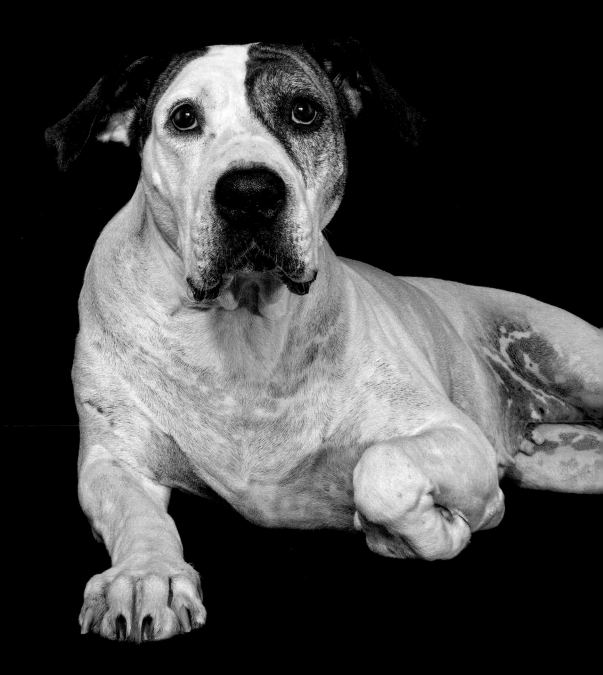

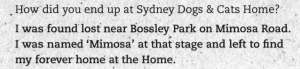

How did you end up at Sydney Dogs & Cats Home?

I was found lost near Bossley Park on Mimosa Road. I was named 'Mimosa' at that stage and left to find my forever home at the Home.

What was your favourite thing to do while staying at Sydney Dogs & Cats Home?

It was probably going for walks with the volunteers. I love going for the same walk every day so I can sniff all the familiar smells.

Who did you love more — the staff or the volunteers?

The volunteers were lovely, giving me lots of hugs, and the staff were very kind in looking after me.

Did you have a favourite staff member or volunteer?

I loved them all equally.

How did you choose your new home?

My new owners loved taking me out for walks. They spoke to me so kindly and wanted to hug me constantly. I just knew they were the right fit for me.

What would you say to potential new guests of Sydney Dogs & Cats Home?

Take a deep breath and relax, you are now in good hands! Your new fantastic home awaits you.

If you could eat chocolate, what would be your favourite treat?

I reckon it would be rocky road with all the special surprises in them.

FOUND We chose Mimi based on her personality profile, which described her as calm and friendly. In addition, I knew her particular breed was known to be 'nanny dogs' as they are very attached to their owners.

Mimi loves going for car rides. When I get ready to leave for work, she will often run past me, climb into the front seat and give me a huge expectant smile.

If guests come over, she starts making funny noises until she gets a bit of something from their plate. She can be very cheeky when it comes to filling her belly, but no one can resist indulging her.

When we take her out, people can be a bit scared of her because she is such a big dog and is not a tiny, trendy designer dog. What they soon discover is that she is the gentlest lady you could ever meet – appearances can be deceiving!

She has definitely changed our lives for the better. My partner and I were going through a rough patch related to our families and Mimi came into our lives right in the thick of it. She is the best comfort you could ask for. Mimi knows exactly when we need a hug from her and is always ready to snuggle.

She loves us both equally, but she loves my partner more when he is in the kitchen, just in case she gets lucky with a treat!

She really is the most loving, kind and gentle dog you could meet.

– *Hasith*

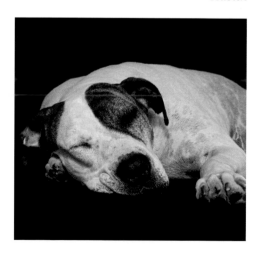

50

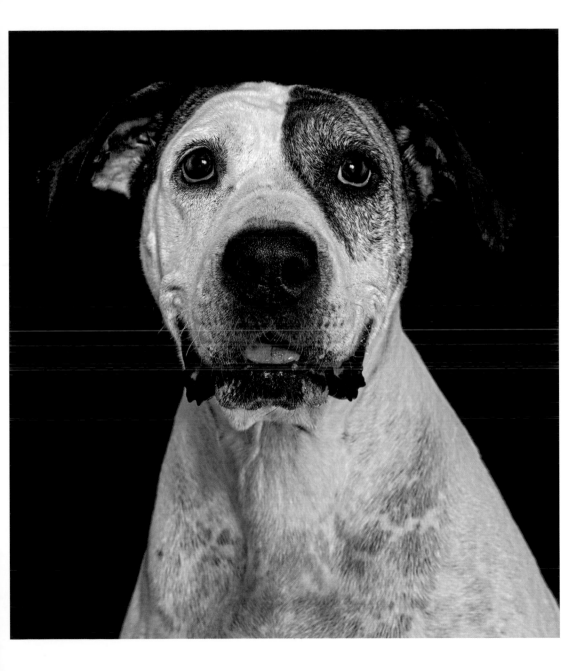

BETTY WHITE

LOST MALTESE-CROSS | 12 YEARS

BETTY WHITE, A GRAND OLD DAME, EMBODIES THE BENEFITS
OF THE SPECIAL CARE PROVIDED BY THE SENIOR PET PROJECT.

When Betty first came in, she was a tottering, neglected stray with dirty, matted fur and putrid breath. Contact was made with her owners, who did not want her back, so Betty came into the care of the Home.

The health assessment was grim. It was clear she hadn't been to the vet in a long time, if ever, and she needed treatment for multiple issues. With no time to waste, a plan was quickly set in motion. First, she needed a complete haircut, as the knotting of her coat was extensive, but even shaved to the skin, Betty was friendly (if a little chilly). Betty bravely underwent major dental work, including the extraction of most of her teeth. She also had surgery for the successful removal of numerous mammary tumours, which were thankfully non-cancerous. The dog who emerged after wasn't the prettiest (yet), but Betty was alert, happy and had a new lease on life. Betty enjoyed three weeks at the Home as the much-loved office dog, spending the days greeting all our visitors. Everyone loved how welcoming and energetic she was.

Then one day, a very special group of visitors came. What happened next was love at first sight.

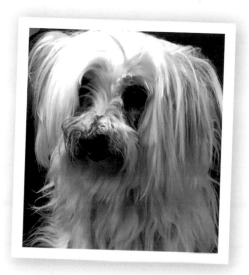

Everyone loves Betty. My friends always ask, 'Are you bringing Betty?' if we're going out. She thrives on all the attention. She can get pretty jealous, but mostly in a cute, harmless way. She's got a sixth sense for when we're getting too friendly with our other pets. If she hears you speaking to or touching one of the cats, Betty White will get up and force you to stroke her instead.

We had a birthday party for Betty, and all her friends came and enjoyed

FOUND We went to the Home to visit a bigger dog, but as we arrived, a tiny white bundle of pure energy caught my eye. Betty White was leaping up and down on her back legs as she strutted by Kelly and me. Then she jumped all over my roommate, Ami, giving us the full Betty White Charm, and it worked. I knew then we couldn't leave her at the shelter, she was clearly family and she had to come home! We adopted her that day.

a cake. She thought it was the best thing ever.

We like to go walking in Sydney Park. Betty trots along happily, but she once had a hilarious moment near the pond. Betty was frolicking over the stepping stones and she walked straight off the edge into the water.

I work from home, so Betty and I hang out together all day and have a special bond. I'm clearly her favourite. I think it's adorable how excited she can get. When we come home, Betty will run right past Kelly to find me. I'm always happy to see her too.

– Lucy

SENIOR PET PROJECT

Approximately 10% of the animals entering the Home are classified as senior pets, aged 8 years and above. Established in 2018, the Senior Pet Project is an initiative that not only puts a spotlight on these golden oldies to help with their rehoming – as seniors are often overlooked – but also to raise the funds required for their much-needed veterinary care and often prolonged stay at the Home.

REASONS TO ADOPT A SENIOR PET

1. They require less exercise
Senior pets tend to sleep more and typically require less exercise than their younger counterparts. If you don't have the time to commit to long sessions at the dog park, a senior pet who likes a daily stroll around the neighbourhood or prefers to chill out at the cafe may be the ideal pet for you.

Senior Pet Project Ambassadors – Adam, Natalie and Chance Goodes
Adam and Natalie Goodes entered the Home explicitly looking to adopt an older dog and provide it with a second chance. They left with Arlo, now known as Chance, who quickly became a cherished member of the family. The Goodes understand the many benefits of adopting a senior pet and are the perfect ambassadors for our Senior Pet Project.

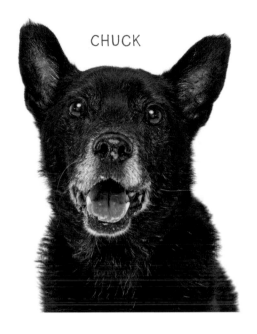

CHUCK

2. Their personalities are already developed

When adopting a senior pet, their personality is already developed so you'll have a better understanding of whether the pet will suit your life-style and fit in with your family

3. Senior pets are usually already trained

Senior pets often already know many skills; this can include toilet training, walking calmly on a lead, waiting for food, interacting nicely with other dogs and much more. The training requirements can be a lot less than those required for a puppy.

4. A smaller time commitment

Cats can live for more than 20 years and dogs typically 10–15 years, depending on the breed. If you're unable to make a commitment to care for a companion animal for that duration of time, or you are not sure where life will take you, adopting a senior pet may be the ideal way to enjoy the unconditional love that only a pet can give you.

5. It's rewarding

Giving a senior a second chance and letting them into your heart is an incredibly rewarding experience.

PUMPKIN

LOST CHIHUAHUA–FOX TERRIER | 5 YEARS

LOVE IS A THREE-LEGGED WORD.

Pumpkin was found roaming the streets without a collar and came to the Home injured and frightened. Her injuries were immediately apparent upon her arrival as she was not putting weight on her left front leg. The vet team went into action, giving this sweet girl pain relief and organising X-rays that revealed a fractured leg and dislocated joint. Poor little Pumpkin would need surgery.

But first, she would need to lose some weight. Pumpkin was severely overweight, possibly due to bad diet or lack of exercise, and had to be put on a special diet. She also needed lots of attention and loved to be close to people. In preparation for her surgery, and with the assistance of some exceptional people, Pumpkin lost almost 10% of her body weight.

Thanks to the support of the Home's generous community, the required money was raised for Pumpkin's specialist surgery through our Emergency Specialist Action fund. The surgeons brought all their care and expertise, but the injury was so old that the bone fragments could not be successfully fitted together. In the end, the hard choice was made to amputate Pumpkin's leg. She came

through the surgery well and within 48 hours, Pumpkin was up and about. Nothing could stop her from playing and running on her three legs. Best of all, she had a new loving family to take care of her.

FOUND We visited the shelter twice. The first time was on a Saturday and there were so many families and so many dogs, so it was a very busy time meeting several small dogs. We decided to go back on a Wednesday when it would be quieter, only to find all the small dogs had been adopted except for one little girl who no one wanted.

The staff were cautious and let us know about her problems and the surgeries that she would need, but after a walk outside with her, we knew that we would be able to give her a good life. After all, she is the kind of dog that needs rescuing.

Pumpkin doesn't bark to let us know when she needs something, so we had a steep learning curve on what her signals were, with a lot of weeing in places that dogs shouldn't wee. She also loves cardboard and toilet paper, so sometimes we will come downstairs and there will be shredded bits strewn around. And in the middle of it all is an innocent-looking dog smiling up at us with toilet paper stuck to her nose.

We have had the discussion several times that if we had known how much work it was going to be to look after Pumpkin, would we still adopt her? The answer is absolutely yes. She brings us so much joy and is such an important part of our little family.

She's given us a different outlook on life. It's hard to complain about your day when a dog with three legs still manages to hop around with a smile on her face and a wag in her tail. All of the care she required after her surgeries have made a nurturing, protective side of us emerge that we didn't know we had. She has taught us so much about ourselves – we're a little less selfish and a lot more tired.

– *Sean and Lauren*

NESSA

NESSA WAS A NEGLECTED SIX-MONTH-OLD PUP WHEN SHE WAS BROUGHT INTO THE HOME BY A LOCAL RANGER.

The vet was very concerned for Nessa's welfare and the initial prognosis was pessimistic. A puppy of that age would normally be energetic and curious, but Nessa was the opposite. She was lethargic and unresponsive.

The staff diagnosed Nessa with hypothyroidism, which had stunted her growth, caused her vulva and nipples to be swollen and enlarged, and a massive goiter to develop. Proper and early treatment would have meant Nessa never had to suffer these symptoms.

Fortunately, Nessa didn't need surgery for the goiter but she was put on medication and placed into foster care with a staff member to observe her closely and to immediately report any changes in her precarious condition. Nessa's demeanour quickly improved with the medical intervention and change of environment, and she began exhibiting normal puppy behaviour, becoming active and playful.

Feeling better and with no owner coming forward, Nessa became available for adoption. And there was no shortage of applicants wanting to meet this adorable Staffy-cross and give her a home.

AN INTERVIEW WITH NESSA

How did you end up at Sydney Dogs & Cats Home?

I guess my previous owners had had enough of my sweetness overload and dumped me, which was a blessing in disguise, because look at me now!

What was your favourite thing to do while staying at Sydney Dogs & Cats Home?

Being at the Home was a breeze – everyone loved me, and really, why wouldn't they? I liked being in the office for some extra TLC and food because how could they resist?

How did you rate the cuisine?

You might not know this, but I was nicknamed Piggy during my stay. Can't think why . . .

How did you choose your new home?

My new owners' hugs and excitement gave me a warm, full feeling, and they don't mind me licking them to death (and the food won me over)!

What would you say to potential new guests of Sydney Dogs & Cats Home?

Be yourself and . . . just quietly, pals, play down your naughty side just a touch. It works a treat.

FOUND Nessa was out on a stroll at the Home when we noticed her. There was something in her silly smile and happy little strut, and we instantly just knew she was supposed to be in our family. She is so gorgeous and loving. Her favourite thing is to share huge wet kisses with anyone who will have them – and that's usually everyone.

Nessa has had a huge impact on our family with her goofy smile and those ears. Her temperament is super infectious and it's impossible to not be happy around her as she brings so much joy wherever she goes.

She has us in stitches on a daily basis with her cheeky personality. One time, she tucked herself under the bed sheets, lying on her back, front paws over the sheet and head directly on the pillows. I should have asked if she wanted breakfast in bed.

She was one naughty pup! She couldn't stop chewing on things, from eating her own bed to gnawing at floor mats, and basically anything she could get her paws on and teeth into. Luckily, she seems to have grown out of it.

We are so happy and grateful we found her and get to have her in our lives, adorable naughtiness and all.

– *Sandra*

TRIPOD

LOST KELPIE | 4 MONTHS

SPECIAL DOGS, AND SPECIAL HUMANS, ARE WORTH THE WAIT.

Tye, a sixteen-week-old Kelpie puppy, arrived at the shelter in the arms of the council ranger. He and his sibling Beau were picked up running the streets. Underweight and ravenous, they had no form of identification and no one came forward to claim them.

Tye was considerably smaller than his brother and his right hind leg was badly damaged, rendering the limb useless. X-rays were taken and a consultation with an orthopaedic specialist organised. The injury was likely to have occurred not long after Tye was born, and amputation rather than corrective surgeries was advised as being in Tye's best interest. Tye remained in foster care for eight weeks with his housemate Ziggy, another former resident of the Home, until his surgery. His surgery went well and he recovered quickly in the care of his familiar foster home.

FOUND We were looking for a second dog to join our family. When we discovered Tye at the Home and learned he had recently lost a leg, we immediately fell in love.

There was no question after our first meeting. We took him home and renamed him Tripod – Tri for short!

ZIGGY

TRIPOD

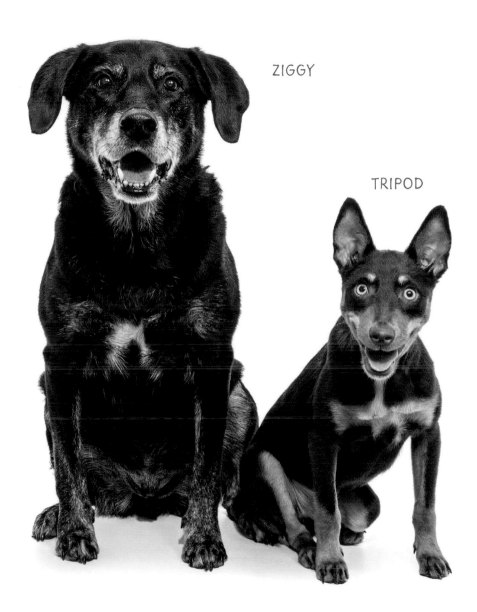

We are so happy having Tri in our lives. He is such a happy boy and our other rescue Kelpie, Luna, is so happy to have a companion at home. Both dogs keep us active and we enjoy adventures as a family, every chance we get.

Tripod has done some very funny things since we brought him home. He loves to try to 'dig to China' through our bed sheets. Unfortunately, this can prove difficult with only one back leg. He has also recently discovered laying on his side and

AN INTERVIEW
WITH TRIPOD

How did you end up at Sydney Dogs & Cats Home?

My brother and I decided to go for a run around the streets when we were picked up by the council ranger.

What was your favourite thing to do while staying at Sydney Dogs & Cats Home?

Sitting on the laps of all the volunteers and team members at the Home. Whenever my foster mum brought me to the shelter, they all thought I was so cute and irresistible that they couldn't put me down.

Did you have a favourite staff member or volunteer?

My favourite would have to be my foster mum!

How did you choose your new home?

I'm very lucky the perfect family found me. My new mum is a vet nurse, I have a Kelpie sibling and best of all, I've got a nice backyard that has been set up for agility training.

What happened to your leg?

I was so little when it happened, I really don't remember, and it has never been a hindrance being a tri-paw. I can still run, jump and play tug.

scratching the bed, which results in him spinning himself in circles. Oh, and he still hasn't reached China yet! We also recently woke up to find all of our couch cushions neatly arranged . . . in the back yard!

Everyone needs to do themselves a favour and rescue a dog. Not only are you helping an animal in need, but they will bring you countless hours of joy and happiness. Tri was abandoned and then lost a leg, but by being given a second chance, we get to watch him live life to the max every day!

– Ana and Dale

ZIGGY

LOST LABRADOR-CROSS | 2 YEARS

SOMETIMES IT'S JUST FATE.

Ziggy was found wandering the streets less than a five-minute drive from the Home. He had a blue collar with a tag, which had his name and a phone number. He was also microchipped and registered with a NSW council.

A friendly, overweight darling, Ziggy had obviously been someone's much-loved pet. The team tried to contact his owners but no one answered the phone or came forward to reclaim him, as he sat waiting in a kennel. And sadly, there he remained. Days turned into weeks and weeks turned into months. In total, Ziggy spent 200 days at the Home before he was adopted.

FOUND It took me ages to find a dog. I knew I wanted to give a rescue dog a home rather than going to a breeder. I didn't need to raise a puppy; I already had plenty of experience with puppies from my childhood. I also really wanted a Rottweiler as I've always been drawn to their colouring, markings and temperament – gentle giants. For months, I searched the various rescue sites and for months a black and tan/brindle dog kept appearing . . . Ziggy. Finally, after searching for four months and with Ziggy still being available for adoption, I called the Home to organise a meet-and-greet. They told me Ziggy

AN INTERVIEW WITH ZIGGY

How did you end up at Sydney Dogs & Cats Home?

I was wandering the streets about five minutes from the Home when a ranger picked me up and brought me in.

What was your favourite thing to do while staying at Sydney Dogs & Cats Home?

I'm a Lab-cross so I loved to eat. Also, I loved my regular walks to the park with the volunteers.

How did you rate the cuisine?

Yummy!

How did you choose your new home?

There were no cats or other dogs, so it seemed like the perfect spot for me to claim as a home of my own.

What would you say to potential new guests of Sydney Dogs & Cats Home?

Even if it takes some time, the team at the Home will work really hard to find you just the right forever home.

Why are you called Ziggy?

I have a kink in my tail like a zig-zag, and Ziggy sounds much better than Zaggy.

wasn't at the shelter as one of the volunteers felt sorry for him and had taken him home for the weekend to give him a break. They gave me her number and I called her. She lived in the next street over from my home and she brought Ziggy over.

What can I say? He walked through my front gate with his head down, giving me no eye contact. He was totally unresponsive when I tried to pat him, he was overweight and, to be frank, he was kind of ugly with his dull coat and broken tail. He was also definitely not a Rottie. However, the volunteer told me what a lovely dog he was, what a sweet personality he had and that she couldn't understand why he hadn't been adopted (I could!). So I decided what the heck, let's give it a go. Eight years later, it is one of the best decisions I have ever made. Within a day, I knew he was a lovely dog.

Ziggy has changed me for the better. I've always been a night owl and a person who loved to sleep in, and I was always very grumpy in the morning. Ziggy however, wakes up with the sunrise and wants to go for a walk. He always has a smile on his face and is so happy to greet the day. After decades of being a night person, Ziggy has made me into a morning person. I now love getting up early – even after eight years it is still hard to believe – to go for a walk.

Ziggy is fearless. The funniest thing he has ever done is juggernaut himself about four metres through a friend's doggy door into the middle of a room while she was having a cocktail party. Imagine their surprise: no dog, dog!

I would encourage people to give a rescue dog a chance. My decision to adopt was the roll of a die but he has been the most amazing companion. Friends who met him in the first few days say he is now unrecognisable. You truly have the power to transform a neglected or abandoned pet's life.

– Faith

PABLO

LOST CHIHUAHUA | 6 YEARS

SMALL IN STATURE BUT BIG IN SPIRIT.

Arriving at the Home in a state of neglect, this little boy with a big spirit was extremely underweight, with his ribs and spine clearly visible. Poor Pablo was also covered in fleas and suffering from flea allergy dermatitis, which made his skin very itchy and uncomfortable.

With no form of identification, the Home weren't able to track down his owners, and no one came forward to claim him. A behavioural assessment revealed that Pablo was good with cats and other dogs, but suffered from separation anxiety, which meant he could become very anxious and

shouldn't be left alone. He thrived in company and while at the shelter, he loved to hang out in the front office. He'd settle himself in an office chair and bide his time until no one was looking then leap up onto the front desk. He was very proud of himself!

Pablo needed a family who would help him with his fears and love him in his imperfect glory.

FOUND We had been looking for a sidekick for our other Chihuahua for a while, but never got the timing right. When Pablo came in, he looked so forlorn and on edge, I

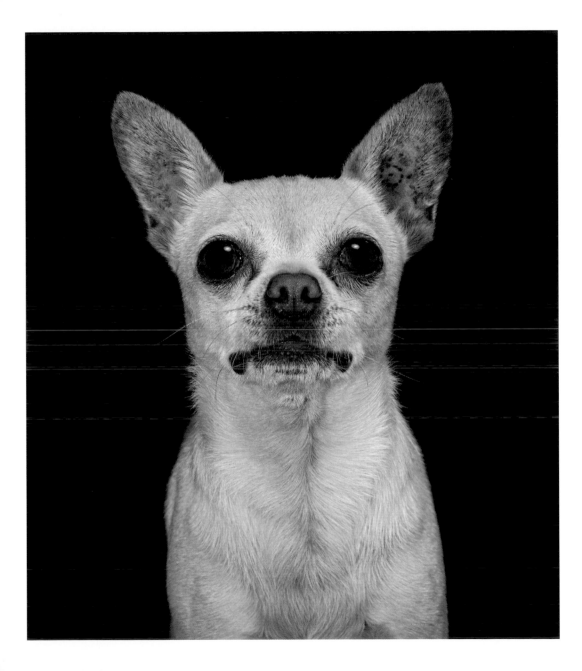

decided to take him home for the week so that he could relax. His guest status translated to permanent resident within a week! This is a condition commonly referred to in the rescue world as a 'foster fail'! His personality gelled well with our household and over time, he became part of the family.

He obviously had a rough start in life, and we saw that in both his personality and appearance. He was very underweight, flea-bitten and had thin, patchy fur from nibbling on himself. He was constantly nervous when he first joined us. We had to adjust our lives to make him comfortable and ease him into the new normality. Pablo made us aware of how small changes by us could make a huge difference for him.

He goes from 0 to 100 when you show him his mini tennis ball. He races around like a little pocket rocket. It's the best thing in the world for him. If he's moody, his mini tennis ball will turn his mood right around.

Adopting a pet with behavioural problems is not for everyone. There are days when you've had a horrible day at work and you just cannot deal with the pet's anxiety, but you stay calm and try not to take it personally. But it can also be very rewarding. You feel great that you have helped an animal that others couldn't, and you feel even better when that animal comes up and cuddles next to you as if to say, 'Thank you for loving me even though I can be moody sometimes.' After all, who doesn't need to be loved, even when they're moody?

Pablo has made us feel like we are doing something important. We could have given up on him, but we chose to change his life and, as a result, he has changed ours. Seeing how he trusts us now makes it all worthwhile.

– Sabrina

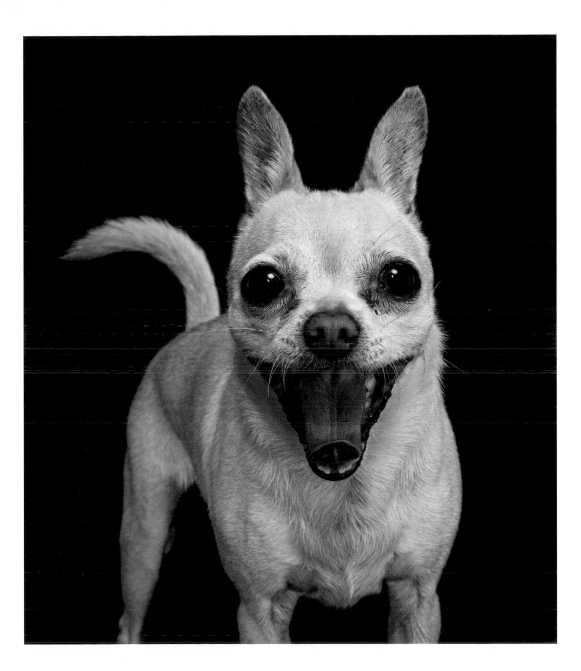

AN INTERVIEW WITH PABLO

How did you end up at Sydney Dogs & Cats Home?

I had been wandering the big, bad streets of south-west Sydney for a while, staying near the shops where I'd get food. A man scooped me up in his car. He was nice and I was allowed to ride in the front seat with him! He took me to the Home where I got lots of attention.

Did you have a favourite staff member or volunteer?

I'm biased. I got adopted by Sabrina, my favourite staff member. But my second favourite person is Alanna. She let me sit on her lap when she answered the phones.

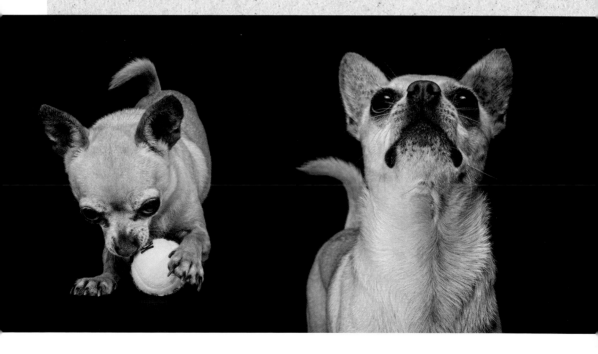

Who did you love more – the staff or the volunteers?

I was very nervous when I first arrived, so the staff looked after me the most. I got to know and love the staff.

How did you choose your new home?

I looked sad and jumped into my new mum's lap. My decision was made!

What would you say to potential new guests of Sydney Dogs & Cats Home?

It can be overwhelming at first, as it's so different from what you might be used to, but everyone (both staff and volunteers) are there to make us feel comfortable. You get yummy food and cosy, plush beds, and if you jump high enough, you can sit at the front desk!

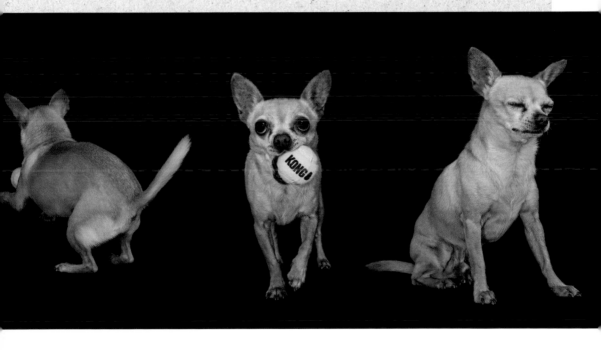

TASHA

LOST POMERANIAN–BELGIAN SCHIPPERKE | 13 YEARS

EVEN A BUDDING ESCAPE ARTIST NEEDS SOMEONE TO RUN TO.

Tasha arrived at the Home four days before Christmas in a bit of a state. She had a flea allergy resulting in inflamed skin and scaly patches, and her ears had chronic inflammation. Tasha also had hair loss over a significant portion of her body, including a large hot spot on the elbow of her left front leg. The little hair she did have was full of flea dirt and her coat had numerous small matts. She was in a bad way and highly anxious. Even though Tasha was microchipped, multiple attempts to contact her owner went unanswered and unreturned.

The vet team quickly developed and implemented a care plan. She was given a full-body clip and bathed with medicated shampoo to soothe her skin. A good quality flea and mite treatment was also administered to treat Tasha's allergies.

To help with her state of mind, the team put Tasha on medication and placed her into foster care to help reduce her anxiety. Tasha began to flourish; her hair started to grow back and her true spritely personality began to shine through. Unfortunately, Tasha was returned to the Home after her first adoption as when she was left alone she climbed the fence and escaped. But there was someone special waiting to become Tasha's forever family.

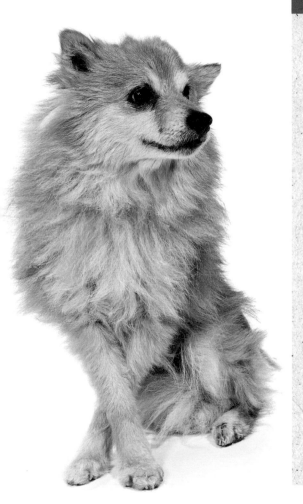

AN INTERVIEW WITH TASHA

What was your favourite thing to do while staying at Sydney Dogs & Cats Home?

Eat! Give me treats and I'll like you or I'll have a treat of you!

Who did you love more – the staff or the volunteers?

While I was there, I was a grumpy old gal and only certain people were able to interact with me. I liked some of the ones who gave me food!

What would you say to potential new guests of Sydney Dogs & Cats Home?

Being in rescue is all right but in hindsight, behave and do all you can to find your new home straight from the shelter. I was lucky to land on my four paws, but so many dogs in rescue have to wait a very long time until they find a home.

FOUND We knew it would be a one in a million person to take Tasha home, but we knew that person was out there, we just had to find them! This is one of the reasons the Home doesn't put a time limit on animals in care. Each animal deserves the chance to find their forever home.

Tasha's profile was shared across social media and was spotted by a dog trainer and rescuer accustomed to difficult pups, who asked to meet her. Tasha obviously liked her a lot, and even let her pick her up, which was previously unheard of! The admiration was mutual and Tasha's new family was found.

Tasha's family have carefully created an environment where she feels safe and they have given her time and space to slowly come out of her shell. It's paid off as Tasha has settled in and has shown off her energy and happy disposition. In her new home, she has adopted a magpie who she likes to offer some of her food to, which is a big deal given how much she loves her food!

In cases like Tasha's, how a dog changes the lives of the family they join is remarkable, but for that dog, how life is irrevocably and wonderfully transformed is magic.

– Faith, Sydney Dogs & Cats Home

CHUCK

LOST KELPIE-CROSS | 10 YEARS

SOMETIMES, A FEW FALSE STARTS ARE ALL PART OF THE
GRAND PLAN TO FIND YOUR WAY HOME, AS WAS THE CASE
FOR THIS SWEET BOY, CHUCK.

Chuck first arrived at the Home as a stray badly in need of dental work. He wasn't microchipped so there was no way of tracking down his owners, and no one came forward to claim him.

With the exception of his teeth, this affectionate ten-year-old was in good health, and after the Home's vets extracted some teeth, Chuck was ready to be rehomed. However, it soon became apparent that staying at the Home was distressing for Chuck's gentle nature and he would not cope if he were to stay there while waiting for a new home. Luckily, the Home

has a wonderful network of foster homes and one was found for Chuck, enabling him to have some time out of the shelter.

Chuck was soon adopted but, sadly for everyone, after only four months, circumstances changed and Chuck's new owner moved to an aged-care facility, where Chuck could not be taken. Chuck once again found himself at the Home but, knowing how stressful a long stay would be for him, the staff immediately found a temporary home with first-time foster carer, Caroline. Chuck spent two months

How did you choose your new home?

I knew right away she was the one! She held me and patted me, and she promised to never leave me.

What would you say to potential new guests of Sydney Dogs & Cats Home?

Daunting! But they will find you a nice place. It was too loud for me and I got anxious, so they sent me to a nice foster home.

What's the funniest thing you have done since joining your family?

I get so excited about my family coming home every day that I zoom around like a bullet! Then I play hide-and-seek, except my vision is terrible so it's very easy for my family to stand still in a corner and hide from me.

What's the naughtiest thing you've done since joining your family?

I'm never naughty! But I don't like being left alone, so I left Alexis a poo-present in the kitchen to let her know. Humans need training!

there, waiting to be found. Fortunately, someone special was looking for him.

FOUND I spent countless days browsing multiple websites, looking for my perfect dog. Then I discovered the Home's site, and my gorgeous Chuck. He had so much sass: back turned, head over shoulder, a big toothy grin. I knew straightaway he was The One.

Chuck is one of the most gentle and loving dogs I've ever met. He can be a little chatty at other dogs, but every person he encounters falls in love with him. The way he gets so excited about me coming home every day is so special for both of us. He zooms up like a bullet, then he wants to play hide-and-seek but his vision is terrible, so I just have to stand still in a corner to hide from him. He's always so happy when he finds me, and I'm so happy we found each other.

Chuck has changed my life and filled me with overwhelming love. He is my little rock, my best friend, and my tiny troublemaker. I can't imagine my world without him. We're the perfect personality pair: both anxious, overexcitable, affectionate and always following someone around. Now, we can do it together!

– Alexis

After a year of being in his forever home, Chuck has unfortunately passed away. Alexis is overwhelmed with sorrow but knows that she and Chuck had an incredible time together, and that Chuck had had a profound effect on her life and mental health. He was loved unconditionally.

MILKSHAKE

LOST GREYHOUND | 3 YEARS

THROUGH HARDSHIP AND HEARTBREAK, SOME WOULD BELIEVE THAT FATE BROUGHT MILKSHAKE THROUGH OUR DOORS.

Milkshake's previous owner trained her to be a racing dog. After she broke her leg on the track in only her second ever race, she was surrendered into the care of the Home.

A lanky, good-natured girl, Milkshake was adopted within several weeks, and was very happy with her new family for the next couple of years.

Unfortunately, Milkshake then suffered a second crisis, and was then diagnosed as having potential PRA (progressive retinal atrophy), a degenerative eye condition that was causing her to go blind. Her adoptive family did not feel they could offer Milkshake the care she needed with her drastically changed needs, so they made the devastating decision to return her to the Home.

Poor Milkshake had gone through so much – it was going to take quite an exceptional family to give her the home she needed.

FOUND Milkshake came into our lives just three weeks after the passing of our beautiful Kelpie girl, Libby. We were completely heartbroken with our loss. Libby had been a rescue dog, a front-leg

88

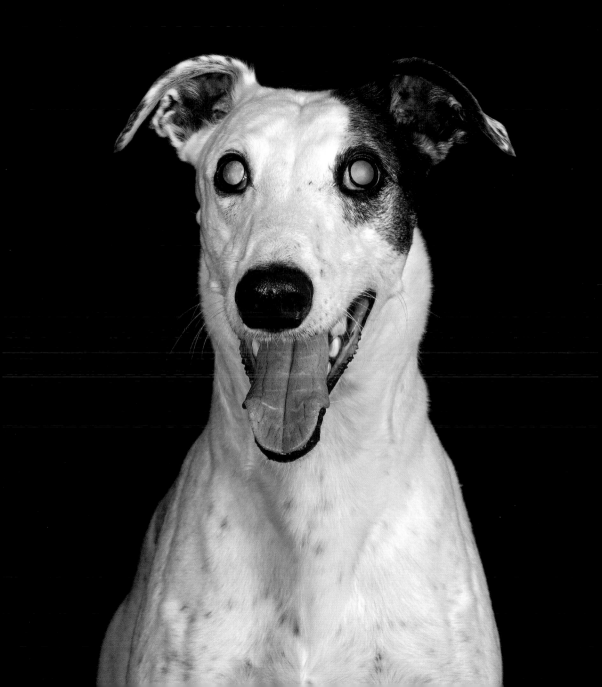

amputee after severe abuse, and had blessed our lives for nine wonderful years. At first, the pain of grief meant it was too much to consider adopting again, but it soon became clear that we were a family in crisis and needed to find another doggie daughter.

While searching various rescue websites, I spotted Milkshake, and was immediately drawn to her. We went to meet her, and my first thoughts were, she is so beautiful and so lonely. The folder of adoption applicants for Milkshake was bulging

. . . of course so many people wanted her. My heart sank as I felt we had no chance of bringing her home with us.

I knew she belonged in our family, so I put in our application anyway. Within a few days, a reply came with fantastic news: we had been chosen to be Milkshake's forever mum and dad.

Our lives have been truly blessed with this courageous, inquisitive, affectionate, cheeky and fun girl. Understanding Milkshake's complexities and perception of the world has been a beautiful journey of spiritual growth.

– *Linda*

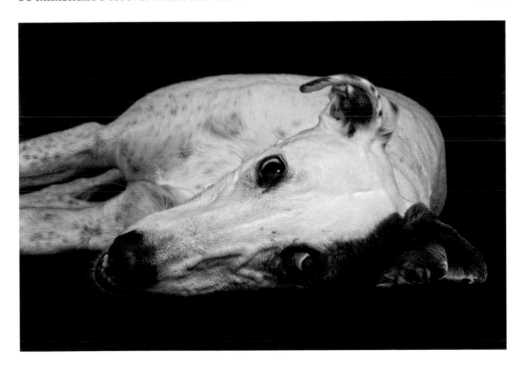

GOPHER

THE MOST LONESOME JOURNEYS OFTEN HAVE THE MOST JOYFUL ENDINGS.

Gopher was brought in as a stray, with horrible ringworm lesions on his face, head, legs and paws. Ringworm is a contagious fungal infection that causes hair loss, skin ulceration and itchiness. Poor Gopher was terribly uncomfortable, but unfortunately, ringworm is extremely contagious, and not only can it spread from one dog to another, but it can also spread to humans, so he had to spend his first weeks at the Home completely quarantined and isolated. Gopher couldn't even go out on walks because of the risk he would spread the infection to the other dogs living in and around the shelter. The team put together a treatment plan for Gopher that would address not only his ringworm infection but also keep this young boy entertained and happy while in isolation.

The team members who interacted with Gopher really had to go the extra mile to ensure they didn't spread the infection, going through what was jokingly called 'the Hazmat process'. They had to be covered from head to toe in disposable protective clothing to ensure they didn't become infected, or pass it on to the other animals in their care. This usually

meant donning surgical-style scrubs, special boots, a hat and sunglasses to protect their eyes. If Gopher noticed anything strange happening, he didn't let on, overcoming his shyness and being warm and affectionate to his visitors.

For the first two weeks, Gopher's lesions were treated twice daily with the application of an anti-fungal cream. He was also given a weekly bath with an anti-fungal shampoo over the quarantine period. To keep Gopher occupied while his skin slowly healed and his coat grew back, the team provided this big-hearted boofhead with lots of enrichment games, toys and treats to keep him busy.

FOUND Finally, after five weeks, Gopher was given the all clear. He found it a little tough integrating back into the Home, as he didn't know how to relate to the other dogs after being in isolation for so long, but the staff worked through it with him, and in no time at all, a wonderful human came forward to adopt Gopher.

As often happens with the dogs at the Home, patience and dedication was rewarded, and Gopher found his forever home.

SQUID

LOST FOX TERRIER-CROSS | 1 YEAR

A LITTLE POSITIVE REINFORCEMENT CAN GO A LONG WAY.

A cute little Fox Terrier-cross, it was estimated that Pirate, as he was known then, was about a year old. He had been picked up as a stray and with no form of identification, the Home were unable to reunite this fellow with his owner. He had come in with a sore paw, and was put on anti-inflammatory medication to treat his injury and provide pain relief. Later, X-rays revealed that Pirate had broken a toe, which was very painful for him, and would take time to heal.

Pirate was a bit anxious with all the noise and activity from the other dogs in the shelter. He was also timid, so somewhere quiet was considered to suit him better. The Home organised for him to go into foster care with a retired couple, where there were no kids or other animals. Much to the surprise of the Home, the couple brought him back the next day, saying that he was exhibiting aggressive behaviour – growling, lunging and barking.

The team had not observed any signs of aggressive behaviour while Pirate was in the shelter and it seemed highly out of character. After a lengthy chat, the Home learned that the couple had been punishing

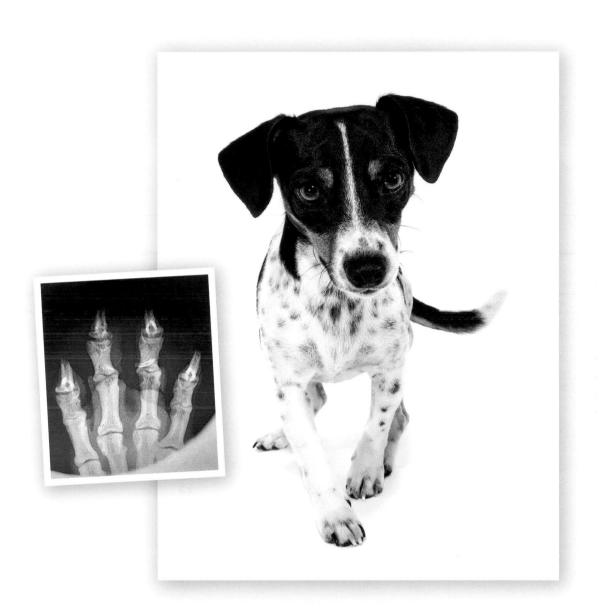

Thankfully, Pirate was back in the Home for only a short time before his person walked through the doors.

FOUND We first saw Squid on the Home's website, and decided we needed to visit him. When he snuggled our hands through the gate bars, we knew we'd found our pet and he'd found his people.

Things have changed a bit since Squid came into our lives. We no longer get to sleep in and our days off revolve around what we're going to do with Squid! And we love every second of it.

Squid loves to go on adventures, from playing on the beach to bush-walking (his Instagram account is @squidtheadventuredog). He can be pretty naughty sometimes, like the time when he squeezed out of his harness in the bushes trying to find rats! We're not quite sure how he managed that. Squid now works with us in the brewery – the dream job!

– *Tero*

Pirate for unwanted behaviour. What the couple perceived as aggressive behaviour was actually a fear-based response to punishment. This is why the Home recommend positive reinforcement for all animals. An owner should reward the behaviour they like and ignore the behaviour they don't like. Reward can be pats, praise, toys, or treats, whatever your dog enjoys and likes.

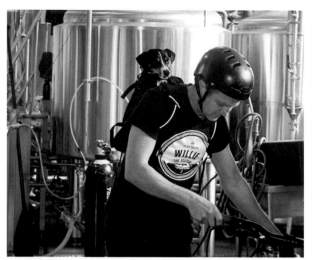

TURBO

LOST WOLFHOUND-CROSS | 3 YEARS

TURBO BY NAME, TURBO BY NATURE. A WHIRLWIND TALE OF
A LARGE PUP WHO FOUND HIS FAMILY.

Turbo was a big, high-octane, boister-
ous pup who was picked up as a stray
and, although he was microchipped,
no one was able to contact the owner.
The team left messages and sent a
letter to the address listed on the
microchip but no one came forward
to reclaim him.

Turbo's stay in the shelter was
brief as a staff member took him into
foster care so he could play with her
dogs and burn off some of his bound-
less energy. And just a few weeks
later, he found a very special forever
home.

FOUND We already had two
Wolfhound-crosses when
we saw Turbo on Instagram. It was a
no-brainer for us, really; we had to
have him!

Our two older dogs have now
passed away, and I'm so grateful that
I have Turbo. He really knows how
to fill up an empty house! He's great
company and I've never been lonely
when my husband, Josh, has been
away. How could you be when you're
getting that much love and attention?

Turbo is now a member of our
family, so of course he comes with us
on all our travels. From Melbourne for

a wedding, to Brisbane for a beach holiday and even to Darwin for one serious adventure! He kept running into the water to cool down whilst playing fetch on a beach there, and we kept calling him to come back, worried about crocodiles.

He can be naughty but mostly, he's hilarious. When we first got him, he got his head stuck in the kitchen flip-top bin lid. He also chased my friend's cows when we were visiting her; he couldn't understand why they didn't want to play with him. He totally destroyed the couch, though. The leather seam was missing a few stitches, so he just dug all the foam out of it!

When I was ten weeks pregnant, we were at a dog training session, and when Turbo saw another dog, he bolted and the lead got caught around my little finger, breaking it. I think he was very sorry. His enthusiasm is all-encompassing and mostly wonderful. He loves swimming and is totally ball crazy; he will drive you crazy wanting to play fetch all day long. His favourite family member is definitely Josh. When Turbo hears his ute coming down the street, he goes absolutely wild!

– Aemelia

AN INTERVIEW WITH TURBO

How did you end up at Sydney Dogs & Cats Home?

Originally I was from Queensland and, to be honest, I'm not really sure how I ended up in a dog park in Leichhardt on a hot summer's day.

Who did you love more – the staff or the volunteers?

Sabrina, of course! But I loved her dogs more. Don't tell her that!

How did you choose your new home?

It turns out there were two other crazy wolfhounds there already, Roxy and Leroy. Leroy mostly liked to chill out but Roxy loved practising her WWE moves on me.

What would you say to potential new guests of Sydney Dogs & Cats Home?

Bring earplugs! Enjoy it, it's a great place and you will probably never get to come back so lap up all the attention!

How many times a day do you want to play fetch?

Is that even a question?

DISNEY

LOST SHAR PEI | 3 YEARS

WHO DOESN'T LOVE A CLASSIC TALE WITH A HAPPILY EVER AFTER?

Once upon a time, on a dark, gloomy day, a horribly neglected three-year-old Shar Pei arrived at the Home.

Without a microchip, collar or tag, Disney was gaunt and in an appalling state. His body was covered in itchy, sore mange and the vet discovered Disney suffered from entropion, a condition where eyelids grow inwards, causing discomfort from eyelashes continuously rubbing against the cornea, which in turn decreases vision.

Poor Disney was malnourished and overwhelmed with pain. The vet took great care in operating to correct Disney's entropion, and the

prognosis was good. Over a number of weeks, the whole team of staff and volunteers at the Home meticulously treated Disney's skin. Severe mange can have lifelong impacts but it is an avoidable ailment. It takes someone who cares to prevent it, which Disney had been lacking. Happily, there were lots of 'someones' who cared about him at the Home.

His body responded well to the change in diet, and the affection and attention that was showered on him made him calmer and more comfortable. His joyful personality slowly began to shine through. The playful boy was also evolving into a

handsome prince, and his glossy coat was his pride and joy. After a long road to recovery and waiting patiently for a fairytale ending, the happily-ever-after came to fruition for Disney and his new family.

FOUND I have volunteered at the Home for over seven years, walking dogs and helping out in the kennels. Over that time, there were several dogs that I would have loved to adopt but, living in a third-floor apartment, I had to settle for two cats. In 2017, we bought a house and before the ink had dried on the contract, I had set my mind to adopting a dog. I thought Disney would have to be an indoor dog due to his skin condition, but Caroline the kennel manager confirmed that Disney would be okay outside. We were still moving furniture into the house when I brought Disney home.

Our lives got quite a bit busier! Disney's skin condition required a lot of care like medication, being washed twice a week and walked twice a day. I loved making him homemade food and spoiling him rotten.

Disney is an immaculate dog. He doesn't dig in the garden and is easily trained. When our daughter found a baby rabbit, she brought it to our house. Disney was amazing with this little animal and he became Thumper's big brother. The rabbit would sit on the dog bed with Disney and then do zoomies around him. Disney would not even react when Thumper jumped on and over him. Disney is also very good with the cats and we've never had any issues with him showing aggression toward them. He is also very good with other dogs, especially with his best friend Freddie, but he can also be quite naughty. And he obviously knows he is doing the wrong thing, but does it anyway! But we wouldn't change him.

The moment Disney became part of our family, we have loved and adored the pooch. He's our Prince Charming.

– Elena

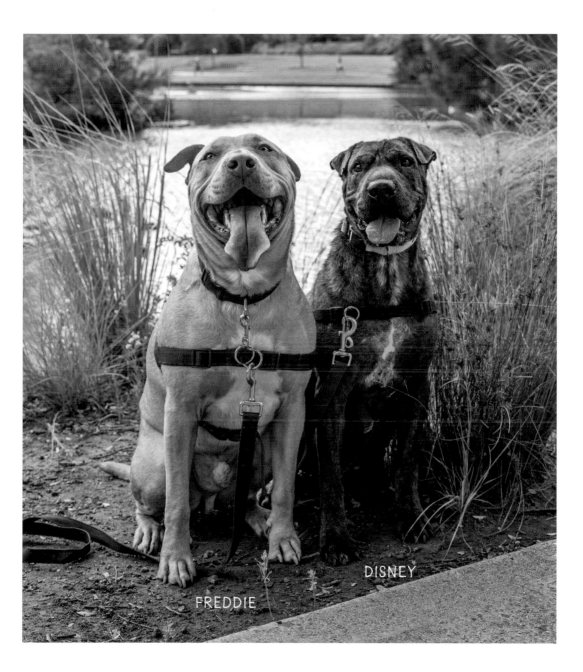

FREDDIE

DISNEY

BENTLEY

LOST AMERICAN BULLDOG | 3 YEARS

WHEN YOU'VE FOUND THE RIGHT HOME, NOTHING WILL STOP YOU FROM STAYING.

A three-and-a-half-year-old American Bulldog, Butters as he was called then, was picked up roaming the street with lacerations and hair loss around his neck. He was wearing a 'check chain' that the team could easily remove by sliding it over his head.

The vet team thought it was likely that the damage to Butters' neck had occurred as a result of him being tied up and then continuously pulling against the chain. His neck was cleaned and gently treated to help it begin to heal.

Butters remained in the Home's care for six weeks. During this time, his palate was also assessed, due to the breathing risks associated with his breed. He had corrective surgery and recovered bravely and brilliantly.

FOUND I have a background with English bulldogs, so I was immediately attracted to Bentley when I saw him on the Home's web-site. Upon meeting him, there was instant bond but two weeks after taking him home, I had an issue with the strata in my unit block.

Poor Bentley had to go back to the Home. He pined for me so much on that the same night, the Home

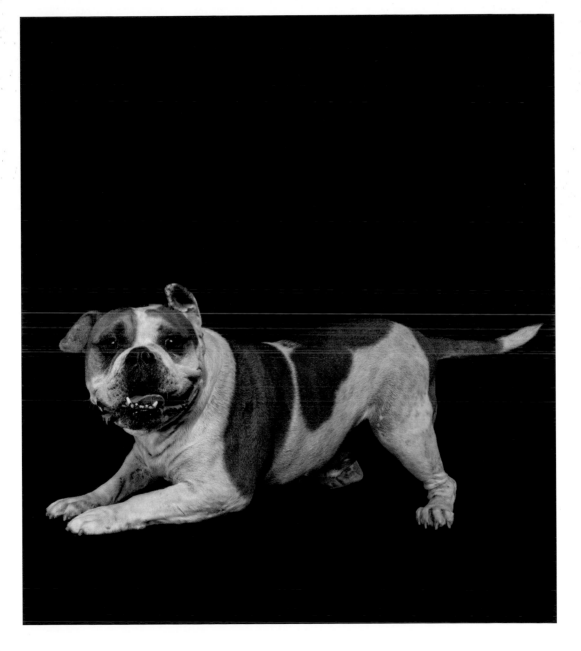

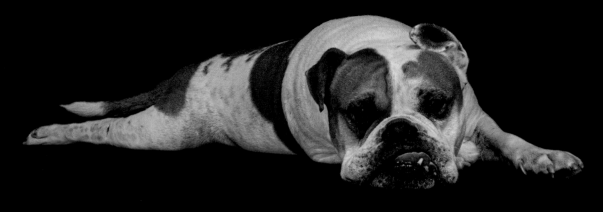

AN INTERVIEW WITH BENTLEY

How did you end up at Sydney Dogs & Cats Home?

I was abused more than once and was in and out of the dogs' home. I don't know why my owners didn't love me.

What was your favourite thing to do while staying at Sydney Dogs & Cats Home?

Sleep and eat!

Who did you love more – the staff or the volunteers?

They all loved me. Look at me, who wouldn't?

How did you choose your new home?

This man came to see me. He looked like me and he smelt safe and friendly, so I liked him. He's now my dad.

What would you say to potential new guests of Sydney Dogs & Cats Home?

Stay safe. You will find a home.

Why do you stick your tongue out all the time?

Because I know it makes me look cute!

returned him to me! I guess when you're home, you're home. The strata issue was eventually resolved, so Bentley and I could be home together.

Bentley has been a constant companion for me. I was diagnosed with CML leukaemia and underwent treatment. I had also been diagnosed with clinical depression when Bentley entered my life. He gave me a purpose: to look after him after he'd had such a hard life. He is also so full of love and affection for everyone. He is always funny and seems to sigh and react to what someone says to him.

He is also always hungry and can smell food out; he constantly looks at you as if he is starving.

Once on holidays in Byron Bay, we were sleeping in a shelter on the beach and I had the lead attached to my foot. Bentley decided to take off after another dog . . . I woke up being pulled along the beach! He just gave me one of his charming, dopey looks and I forgave him immediately.

– Peter

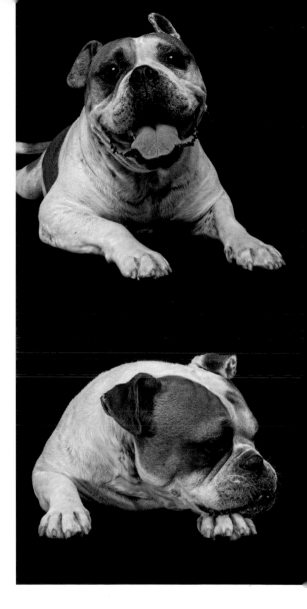

DOROTHY

LOST STAFFY-CROSS | 1 YEAR

SADLY, NOT EVERY ANIMAL WHO ARRIVES AT THE HOME IS IN THE BEST OF HEALTH.

The team was particularly challenged when the ranger brought Dorothy into the Home after she'd been abandoned at a veterinary practice.

Dorothy had a serious case of demodectic mange and a terrible skin infection. She had lost almost her entire coat of fur and nearly every centimetre of her body was red raw, inflamed and covered in scabs, and there was a strong odour emanating from her infected skin. She was also extremely underweight.

The animal care manager said she had never seen such an extreme case of mange in the Sydney area. 'What's really heartbreaking is that Dorothy's condition had not occurred overnight but had worsened over weeks or even months. Since she was only six months old, this meant that much of her life had been spent suffering from this itchy and painful condition.'

Despite this rough start to life, the team saw from the very first moments that Dorothy was a very happy, friendly girl with a loveable demeanour. They immediately set out to get her settled and comfortable, giving her pain-relief medication and antibiotics to treat her infection. Dorothy was also given medication

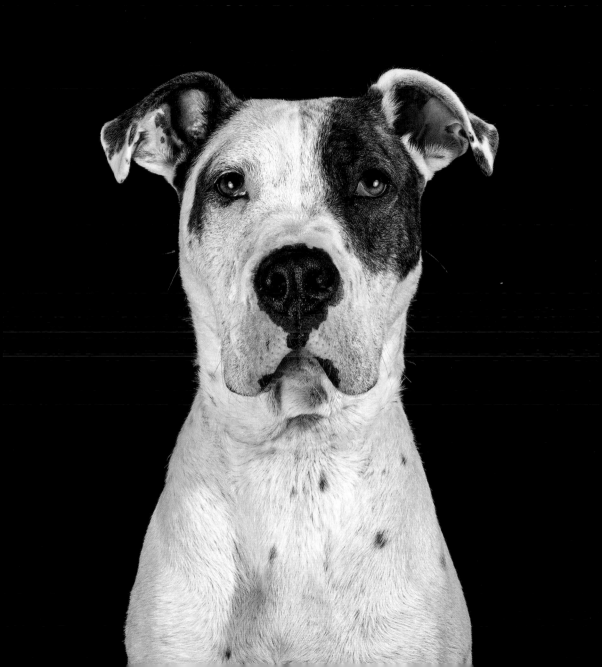

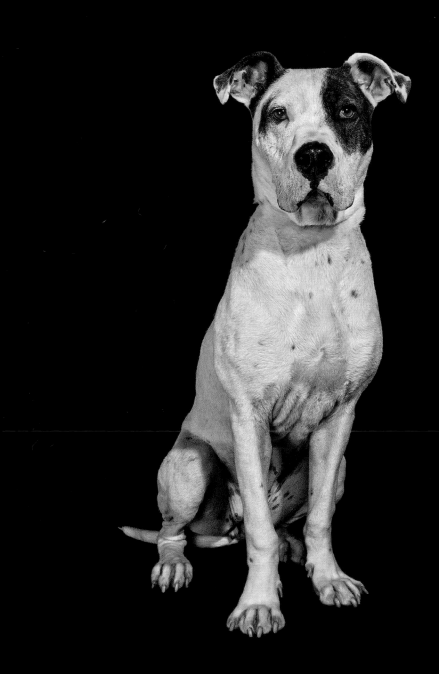

to kill the millions of mites that were covering her weakened body and the root cause of the mange.

A protocol of antibacterial baths, followed by treatment with a soothing conditioning lotion every second day was put in place and followed diligently. Dorothy was also put on a diet of puppy food to help her gain weight.

FOUND Dorothy was adopted by a lovely family who had to return her because they could no longer care for her due to illness. She was then adopted again, but returned when the dog who was already in residence didn't want to share the same space with this gorgeous lass.

At the time of publishing, Dorothy remains in the care of the Home. It has been nine months so far, and she is still waiting to find her forever home.

COMMON SKIN ISSUES

DEMODECTIC MANGE

Caused by Demodex mites, mange is a skin disease that results in hair loss, scabs and lesions. It can also result in skin infection that causes severe itching. Nearly all dogs carry Demodex mites without developing the symptoms of mange. Symptoms occur when the infestation of mites is so great it overwhelms the dog's immune system or, conversely, if the dog already has a compromised immune system (e.g. an older dog, a young puppy, or an ill dog) and it is too weak to fend off the mites.

Mange can be prevented with the use of an anti-parasitic product for mites. Many flea and tick products also protect against mite infestations, and this will be stated on the packaging. If your dog does develop a skin condition, the Home would always recommend you consult your vet to accurately diagnose the underlying cause.

FLEA ALLERGY DERMATITIS (FAD)

Flea Allergy Dermatitis is one of the most common causes of itchiness in dogs. Some dogs are allergic to the saliva left behind after a flea bite. The allergy is so intense that even a single flea bite can cause a dog to itch and scratch incessantly for a prolonged time. FAD can cause your dog's skin to become irritated and raw, and it can even result in hair loss. If your dog is exhibiting symptoms of excessive grooming or scratching, it is best to consult a veterinarian to have the symptoms accurately diagnosed.

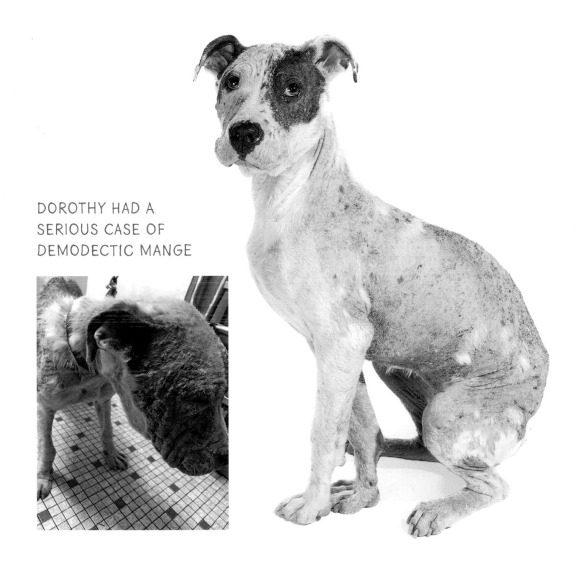

DOROTHY HAD A
SERIOUS CASE OF
DEMODECTIC MANGE

FONZY

LOST MALTESE–SHIH TZU | 8 YEARS

IMAGINE COMING BACK FROM HOLIDAY TO FIND THAT YOUR BELOVED FAMILY PET HAS GONE MISSING.

There are messages on your phone from the local shelter and a notice in your letterbox explaining that your pet is in their care and if you don't reclaim your pet within two weeks, it will become available for adoption. You call the shelter immediately but it is too late! Your pet, who had been in their care for twenty days, has been rehomed. If another 24 hours had passed, this would have been the reality faced by Fonzy's family.

They had been on the dream overseas holiday of a lifetime but returned to find a nightmare: their precious pooch was missing. Fonzy had been entrusted into the care of a family friend, but somehow ended up wandering the streets. He was picked up by a council ranger, who brought him to the Home when he was unable to reach Fonzy's owner. The pet-minder who lost Fonzy didn't tell the family he'd gone missing and didn't know how to find Fonzy.

Thankfully, Fonzy's family contacted the Home as soon as they received the notifications when they'd arrived back in Australia. Fonzy has now been reunited with his family.

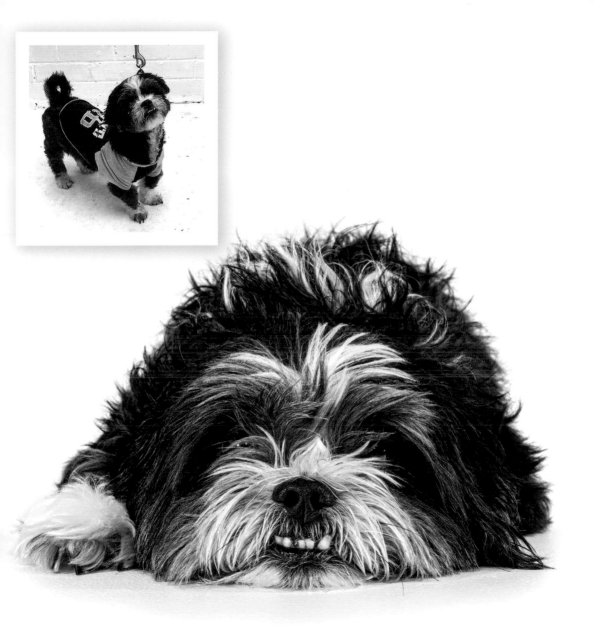

How did you end up at Sydney Dogs & Cats Home?

My family was planning a holiday to Cyprus for seven weeks. I know they would have loved to have taken me with them, but it really wasn't possible. I had to stay with Andrew and keep him company. After several days at Andrew's place, I was getting a little homesick and wondered how long it would take me to get back home. Or maybe I could just go and visit my house then I could get back to Andrew's before he got home.

It wasn't long before a man and a woman were reaching out to me. I knew that Mum had her number on my collar and if they could just call her, everything would be fine. They tried so many times and they even took me inside, fed me and gave me a warm place to sleep until the morning. I couldn't understand why Mum would not answer her phone and come for me. I felt so sad. In the morning, the lovely couple took me to a vet who called for the ranger to pick me up and take me to the Home. Everyone was so lovely there and I knew I was safe, but I missed my family.

How did you rate the cuisine?

I'd lost a lot of weight on my arrival to the home and wasn't in the best of health. So as tasty as the cuisine was, it took me a little while to enjoy eating again.

What was your favourite thing to do while staying at Sydney Dogs & Cats Home?

I made so many new friends and looked forward to my daily walk in the surrounding streets.

Who did you love more – the staff or the volunteers?

Everyone gave me so much attention and the best of care. I really couldn't tell who were permanent staff and who volunteered their time as everyone seemed so

comfortable and suited to their roles. They must all really love what they do.

How did you choose your new home?

Thankfully, on my family's return from overseas, they came to pick me up. They had no idea I was missing until they arrived in Sydney. Andrew told Dad, who broke the news to the rest of the family in the car ride back home from the airport. At this point, Andrew did not know where I was. It was only once Mum arrived home and listened to her voice messages that she knew where to find me.

What would you say to potential new guests of Sydney Dogs & Cats Home?

Although I was microchipped, Mum was very sad that she did not think about changing her contact details, possibly to Andrew's, while my family was away. I would strongly advise you to ensure microchip contact details and pet registration details are all up to date. We were so fortunate that the Home was able to look after me for such a long period before I was reunited with my family. My big sister Thaliah is now volunteering her time to the Home as a way to give back to such a wonderful service and facility.

FOUND Fonzy has brought so much happiness to our family and has helped make our house a home.

Each member in our family shows Fonzy compassion no matter what mood they may be in. He is adorable and so lovable. The greeting we receive from him when we arrive home, no matter what time of the day, is absolutely priceless.

Fonzy seems to love us all equally but knows who will give him extra treats when they shouldn't, who gives more cuddles and who will play with him no matter what they are doing.

– Athena

BEAU

LOST LABRADOR | 9 YEARS

EVEN LOSING A LEG COULDN'T KEEP THIS OLD DOG DOWN.

This handsome older Labrador was named Bo when he arrived at the Home. He had a large mass protruding from his left hock but was otherwise in good health and had a beautiful demeanour. He had obviously been someone's much-loved pet, as he walked well on lead and knew a few tricks, so we did an extensive search for his owner.

Sadly, Bo was not microchipped and no one came forward to reclaim him, so after seven days, Bo was transferred into the care of the Home.

The vet took a biopsy of the mass and sent it off to pathology for diagnosis. The results revealed that Bo had a mast cell tumour, which is common in both Labradors and older dogs. Bo would require surgery to remove it and the team immediately set about liaising with an offsite vet clinic to organise access to a surgical theatre.

During the surgery, it was found that unfortunately the mass had spread further than initially thought, infiltrating the surrounding tissue and tendons. There was simply no way to remove the tumour while leaving a sufficient margin of healthy, non-cancerous tissue.

How did you end up at Sydney Dogs & Cats Home?

I arrived as a stray, then two months later I had my back left leg removed to ensure all the cancer on my foot was gone.

What was your favourite thing to do while staying at Sydney Dogs & Cats Home?

Recuperating from my operation. I had a bed behind the desk and all the staff were great company. Then I got to go to a great foster home for a month.

How did you rate the cuisine?

I'm a Labrador: all food is good.

Who did you love more – the staff or the volunteers?

Both equally.

How did you choose your new home?

The third lot of people who came to meet me thought I would like the life they could provide for me, and I liked them.

What would you say to potential new guests of Sydney Dogs & Cats Home?

Hang in there. Your forever home is coming, even if it does take 87 days, like it did for me.

The team was faced with a very difficult decision on the best course of care for poor Bo, and concluded that the best treatment option was to remove his left hind leg, ensuring the cancer was completely removed. Once again, access to the third-party vet clinic was organised and the surgery booked in. Being an otherwise healthy and active dog, Bo was the ideal surgical candidate and the operation went smoothly.

Post-op, Bo was brought back to the shelter for observation. In less than 24 hours, he was up and about, negotiating his way around the admin office with aplomb.

FOUND My fiancé John and I were looking for a black male Labrador to adopt. John saw Beau as he came down the lift in his office building. The lift doors opened and it was love at first sight; he didn't even notice that Beau had three legs until later, he was so taken with his big personality and gorgeous face.

Coming home is now wonderful, as we receive an amazing welcome-home happy dance. He then wants to chat, leaning in against you and talking, probably telling you how much he missed you.

Beau has a lot of love to give, and he loves to give it.

– *Karina*

POE

LOST | SILK TERRIER-CROSS | 12 YEARS

IT ONLY TAKES ONE SPECIAL PERSON TO CHANGE A DOG'S LIFE AND ONE SPECIAL DOG TO CHANGE A PERSON'S LIFE.

Twelve-year-old Poe arrived at the Home in very poor condition. He was picked up by a concerned resident who handed him in to a local vet. Poe was severely neglected, underweight and with fur that had become so matted around his head, he was unable to fully open his mouth. He also had a heart murmur and dental disease. Untreated dental disease is very common in the older dogs arriving at the Home, which is terrible because poor dental hygiene can have a terrible impact on a dog's general health.

Poe was not microchipped so there was no known owner.

Luckily for Poe, a member of the vet team where he'd originally been taken in volunteered to provide him with foster care. When no one came forward to reclaim Poe, his foster mum immediately adopted him.

FOUND I remember the day I first met Poe so vividly. It happened at the clinic, where I work as a vet nurse. A man brought him in in a metal cage. He said he found this stray dog wandering around his front yard. He said he wasn't sure what kind of creature he was when he first saw Poe, given the state of him. The

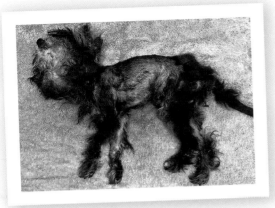

vet and I took Poe into a consult room and took a closer look at him. He was covered in so much matted fur, some of which had even formed dreadlocks, that we couldn't even tell where his limbs started. It was the most severe case of neglect I had ever seen. We scanned him for a microchip but he didn't have one. Another vet was called in and they were considering euthanasia on humane grounds, as not only was Poe in horrible condition but they could tell from the cataracts in his eyes that he was an old dog and predicted that he would be suffering from age-related health issues.

As they were contemplating his fate, I looked into his eyes and offered my hand to his face. He gave me the tiniest lick across the top of my hand. It was almost like he wanted to tell me he still had some life left in him. I felt a connection instantly and asked the vets if we could give him a bit more time. They agreed, so we gave him some pain relief and started shaving him. We found that his matted fur was so bad, his waste had become stuck amongst the fur near his bum and had attracted maggots. We removed the maggots, but it made him become very agitated and we had to leave him to rest with his head and some of his body unshaven.

I cried a lot that day, but that night I imagined what I would name him if I could keep him and 'Poe' sprang to mind. I came into work the next morning to find the council had been called. When the ranger had arrived, I made sure to tell him that I named the dog Poe. Although I felt sad saying goodbye, I was relieved to

know the Home would know exactly how to take care of him. I found it hard not to think about him. For the first few days, I would call the Home for updates. They had finished shaving him and run bloodwork, which showed some underlying health issues that needed to be treated.

Eventually, they asked me if I would like to foster Poe. At first, the thought of fostering an old dog intimidated me as I had never fostered a dog, let alone an old dog who would require extra care. But I knew I could give him the love and support he needed and I agreed to fostering him. However, before I could take him home, they wanted to make sure he would be safe around my two dogs, Maxine and Cachupin, and suggested I bring them down to meet him. This made me nervous because Maxine could be a little unfriendly with other dogs. Her decision to accept him or not would be the final decision as to whether we would be taking Poe home. Maxine is blind so she couldn't see Poe, but there must have been something about him that she liked because she accepted him straightaway. I cried the whole way home because I was so happy to finally have Poe back in my arms.

The tears kept flowing when I got home. My sisters cried and gave him cuddles. They loved him as soon as they saw him. My mum took one look at him and cried, understanding why I was so passionate about looking after Poe. But there was one more person who Poe needed to win over. When my grandmother heard the news, she refused to come inside because she thought it was crazy that we were taking on another dog. We explained Poe's special circumstances and managed to coax her inside the house. My grandmother took one look at Poe . . . and burst into tears. She then asked to hold him and I knew then that she also understood why he needed me.

I set him up in his enclosure with the supplies that the Home

had provided to properly care for Poe. They were very helpful in ensuring that Poe would have everything to make himself at home. They asked that I keep a journal of Poe's health progress so that they could keep tabs on him regularly.

That night, we cuddled with all three dogs and watched *Kung Fu Panda*. I decided that it was Poe's favourite movie. He fit right into our family and it almost felt like he had been with us the entire time. I had to work the next day, so my partner, Brandon, offered to stay home and look after him to ensure that he settled in comfortably. I was so excited to come home to see Poe. He had stolen my heart and I had already decided that I would be adopting him once I was allowed to.

The Home and I agreed that it was more convenient to take Poe to see the vets at my clinic. The vets had already met Poe and were happy to see him looking much more alive

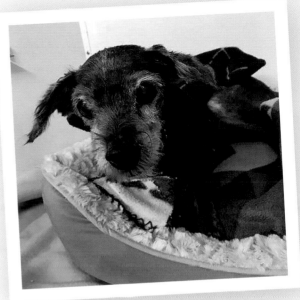

than he had on his first visit. Upon hearing about my concerns about Poe's persistent cough, the vet put him on some heart medication. She then told me that he was a very old dog and, due to his bad heart and history of neglect, I might not have him for too long. Although it was sad, I was grateful for her honesty. It allowed me to prepare myself for the possibility of only a short time

together. We started him on his heart medication and his cough improved. He started to show more of his personality as his confidence grew, and we learnt that he was an old dog with a young and gentle spirit.

We tried to give Poe the life he deserved. We took him for short walks and showed him some beautiful places. We took him to lookouts to watch the sunset and to lakes to watch the ducks. I would carry him in my arms when I knew he had walked enough, so he never missed out. We would have cuddles with him in bed or on the couch where he would fall asleep on our chests. We had established a routine and he now knew his way around the house. He loved to walk the length of the house, follow Maxine around to sniff her butt and snuggle with Cachupin.

A few weeks passed and it was decided that I would be able to adopt him. My feeling of happiness that day is something I will never forget. My family was thrilled.

After about three months, I noticed that he wasn't eating as much. I was worried but knew that it was quite common for older dogs to be fussy with their food, so I changed it up every few days to encourage his appetite. It didn't work as well as I'd hoped. When I woke one morning to find Poe was lethargic and had developed diarrhoea overnight, I rushed

him to the vets. Blood tests showed that his kidneys weren't functioning well enough. The vet advised me that due to his heart condition, it would be risky to flush out his kidneys. The only option was to start him on kidney medication. She then warned me that if it didn't work in the next 48 hours, it might be his time. That night, we started him on the medication, and I prayed that it would work. The next day, to everyone's surprise, he perked up and was brighter and alert. He wasn't ready to go just yet.

As the days passed, he seemed to return to his normal self. I was so relieved that I had more time with him. We started him on a new diet that would help his kidneys function and he seemed to love the stuff. He was more active, so we continued to take him out for little adventures. We were cautiously hopeful this might mean we'd have him around for longer than we'd initially thought.

After another two months, Poe was slowing down and seemed to get a bit confused every now and then. His old age and health issues seemed to be finally catching up with him.

I remember the day my sister called me and said that Poe was sick again. I took him to the vet that same day, where they told me to monitor him at home. He was okay for about a week. I took him to work on Thursday, when I was the opening nurse. The vet examined him and was concerned that his body was struggling to regulate its temperature on its own.

Poe stayed with me at work that day. We kept a heater near his kennel to keep him warm and his temperature was slowly increasing. He was looking slightly better. I would give him kisses and cuddles to make sure he knew I was always nearby. When it was time to go home, I consulted with the vet once more and he told me that we were reaching the end of Poe's life and that the most I could do at this point was to make sure he was comfortable. I would soon have to make an important decision. And I

was afraid that I would have to make that decision in the middle of the night. The vet kindly offered to meet me at the clinic if that happened.

And so it was the next morning, at 3:30 am, when Poe took his last breath. Brandon and I held him and told him how much we loved him. He died in our arms.

I felt a void left behind after his loss. He had become such an important part of my life. It felt strange that I didn't have to wake up so early in the morning to toilet, medicate and feed him, or come home from work and do the same. It felt strange that he was no longer there to give kisses to and to give me cuddles. I cried many tears. Although I had only known him for six months, love knows no time. I had learned to love him so much in such a short time.

Of course, all wounds heal over time and it helped to think about the little things Poe did that made me smile, like how he would pace up and down the house like a little old man, doing his daily exercise. Or how cute he looked when his fur was tied up in a man-bun, and how dirty his face would get when he ate because he felt the need to stuff his face into his food. How he would spend forever trying to find the perfect place to poop in the backyard and then run around in excitement after he had done it. And how his cuddles could almost magically make me feel better whenever I was sad.

My experience with Poe is the perfect example of how rewarding it is to adopt a senior dog. I would do it all over again. I feel closure knowing that Poe lived his best life before he left this world and that he will always be remembered. Poe taught me so much about patience and unconditional love. His strong will to live in the face of adversity inspires me to never stop fighting for what I want in life. His spirit lives on in the lessons he taught me and in the memories of him that we keep and cherish.

– Isabel

OPAL

LOST | SIBERIAN HUSKY | 3 YEARS

A STUNNING PURE-BREED SIBERIAN HUSKY, OPAL WAS
A REPEAT OFFENDER.

A proficient escape artist, she was a guest of the Home three times over three years. Thankfully, the rangers were always able to capture her before she got injured or hit by a car.

Anyone familiar with the breed will know Huskies can be challenging dogs to train. Ultimately, Opal's owner decided she was too much of a handful and made the decision to surrender her into the care of the Home so that she could be rehomed with someone who could give her the home she needed.

FOUND One of my roommates had a dog from the Home come to their office and sent a photo to our group chat. All the girls I was living with wanted to go see all the dogs at the Home. I wasn't as keen but I was the only one who had a car, so I was dragged into driving them there. Once I saw Opal, I fell in love. It was an instant connection. I took her for a walk and knew this crazy girl had to be mine.

Sadly, she was originally given to another owner and I thought she was gone for good. About two weeks later, I got a call from the Home asking me

as she tried getting out the window behind the bed. After waking up and seeing her going crazy, I tried to calm her down, but she was so wound up, she couldn't stop. So we took her outside and she jumped up and down for the next twenty minutes before finally calming down. That level of excited energy is still there, every day.

Opal has changed my life in more ways than I could ever have imagined. From having to get up at the crack of dawn for morning walks, tripping over her toys all around the house, having her jump from her bed onto mine in the middle of the night . . .

The amazing thing about Opal is that she is the most sweet-natured animal you could ever meet. As soon as someone comes into the house, she gets very excited and has to greet them by jumping all over them. Whenever we go for a walk, she has to say hi to every single dog in sight. As soon as she sees another dog, she will pull on the lead very strongly and jump up and down on her back two

more questions about Opal. I knew that she was back and this call was going to be life-changing. It was fate. They asked if I wanted to adopt her. I cancelled my afternoon appointments and went straight to the pet shop, got her a collar, lead, bed and a toy before picking her up that afternoon.

She was obviously very excited to be in her new home. While I was asleep, she was too excited to sleep. At some crazy hour in the morning, a sensor light came on outside and Opal got so excited and started jumping all over the bed, then all over my face

How did you end up at Sydney Dogs & Cats Home?

My last owners took me there when I was too crazy for them. They couldn't keep up with me.

What was your favourite thing to do while staying at Sydney Dogs & Cats Home?

Meeting all the other dogs in the Home. They were always so nice to me and I loved making so many new friends.

How did you rate the cuisine?

Let's just say I wouldn't hire the chef at my next birthday party. But the staff always made sure I was fed and helped me fix my eating problem.

Who did you love more – the staff or the volunteers?

They both were amazing to me. You could tell when they spoke to Josh how much they loved me, and they always expressed excitement when talking about me.

Did you have a favourite staff member or volunteer?

Not really. They all loved me very much. They were all my family and I don't have a favourite family member.

How did you choose your new home?

There was only one person who was crazy enough to take me into their home and we have been best friends ever since. Josh also has amazing roommates who look after and love me.

What would you say to potential new guests of Sydney Dogs & Cats Home?

You are very lucky to be in such a great place with amazing people. You're probably not in there for the best reason but going to the Home will change your life and be one of the best things that will happen to you. From there, you will meet the love of your life.

What is your favourite game you like playing with other dogs?

It would have to be Opal tag. The way Opal tag works is that I see a dog, I jump on their back or jump in their face, then I run away. They should start chasing me. It has to be at a big park because I like to fly to the other end of the park and back as other dogs chase me. If the dog doesn't chase me, I will keep jumping on them until they eventually chase me or I'll find another dog to chase me. I'm not too fond of chasing other dogs but I love it when they chase me.

paws to pull me towards the other dog to say hi.

Of course, looking after Opal comes with some very serious responsibility. Making sure she is fed every morning and night, making sure she gets a walk in every day, often twice a day. Being a sole owner, you have to make plans based around her needs.

I think the biggest way she has impacted me is the happiness she brings into my life and the lives of those who meet her. It is incredible how many people stop to pat her or point at her from a distance; as soon as anyone walks past her, you see an instant smile from them as her presence brings joy to everyone's day. This is definitely how I feel. Waking up next to her is the best way to start the day and as soon as I get out of bed, she flies off in excitement; her energy is the best way to start the day.

I have seen a massive change in Opal since rescuing her. When I first adopted her, she was very skinny and tiny and didn't eat much at all.

She would barely touch her food and it was as if we had to teach her how to eat. She wasn't originally toilet-trained at all, so there was a lot of training involved early on.

There has been a big change in Opal's mental side too. She is more confident around us as well as being a lot happier. She didn't make any noise before but now when playing she will howl and bark. When we first went on walks, she was absolutely crazy, trying to take off anywhere, pulling me left right and centre, as well as trying to get her lead off to escape. Now she's a lot more controlled but still excited to go for walks.

She also used to hate the water at the beach and run away from it. Now, as soon as we get to the beach she runs straight to the water and splashes around in it, like the happiest dog in the world.

– Josh

SATURN

LOST KELPIE-CROSS | 18 MONTHS

THIS HIGH-ENERGY PUP WAS WAITING FOR A FAMILY
WHO COULD KEEP UP.

Hit by a car, Saturn was picked up by a ranger and brought into the Home. She wasn't microchipped nor was she wearing a collar with tags to identify her or her owner.

Saturn was limping on her right hind leg and the team initially thought it was slight bruising and with rest, she'd make a full recovery. However, an X-ray of the leg and a physical examination revealed that Saturn had a ruptured partial cruciate ligament. The team put her leg in a splint to stabilise the joint and gave her a course of pain relief. She was also put on 'rest protocol' and sent to a foster home where she could rest and recover. Over time, Saturn's knee stabilised and she was ready to find her forever home.

This delightful little pocket rocket spent almost four months in the Home's care before meeting her forever family.

FOUND We'd been looking for a dog to complete our family for quite a while. We saw Saturn on the Home's website and decided to meet her that weekend. When she came out to meet us, she was so excited and gave our three

boys the biggest cuddles! After a walk around the block together, we knew she was our perfect match. She came home with us there and then. Our boys couldn't believe their luck.

Saturn has given our boys a reason to run home from school each day. She loves going for walks each morning and then curls up at our feet. She's very keen to learn tricks, race around the backyard and loves giving huge cuddles. She knows she's loved and she loves us in return. She provides love, laughs, company, cuddles and lots of entertainment.

She does have one slightly annoying habit. Chewing. Lots of it. Everything and anything! Clothes, doormats, outdoor furniture, bike pedals, hose nozzles . . . anything she can get her cheeky paws on! Saturn also has a crazy sleeping position

when she is zonked out in her bed at night. She's on her back, belly up and snores contentedly. She must rest well, because she's always up early to wake us up with kisses on the face.

We are very lucky to have adopted Saturn. She is an amazing, gentle and smart dog who bring us so much joy and we know she feels lucky too.

– Jo

ROB

THROUGH THE DARKNESS, ROB'S LIGHT SHONE THROUGH.

This big, boisterous boy was found tied to a fence in a park, deliberately abandoned by his owner. The team named him Rob in honour of the ranger who found him and brought him in. Rob was a big, strong dog with terrible lead manners, constantly pulling and overly keen to be in control.

In the Home, Rob showed signs of poor socialisation. He liked to jump up on people and we didn't know how he would get along with other pets including dogs. His behavioural assessment indicated a high prey drive, an instinctive inclination, which meant whoever adopted him would need to watch him closely around smaller pets and animals, such as cats, birds and rabbits.

It was also learned after his first failed adoption that Rob could be very destructive in the home, destroying soft furnishings and chewing on things that he shouldn't.

Rob's most redeeming feature was always his incredibly affectionate nature as he is always up for a snuggle and he simply adores people. The trick was to find someone who could put the time and effort needed into Rob's training so he could learn the right way to interact and behave.

FOUND I was a volunteer at the Home and kept seeing all these dogs getting adopted while Rob sat in the corner of his kennel. He seemed so sad to me, left there by himself. When my husband came to help out too, I asked him to go into Rob's kennel to keep him company. The rest is history!

When we adopted Rob, we made a commitment to make sure he received the right training so he could learn the correct way to behave. It's a bit like having a new baby, but so worthwhile. It doesn't mean he's not still a bit cheeky and occasionally hilarious! One time, he tried to take over the cat's bed – watching our big, tough-looking boy trying to squeeze into that little bed was pretty funny. But he was determined and he did it, and then he proceeded to sleep there!

He has changed our lifestyle completely. We're so much more active now because he needs to be walked for 40 minutes in the morning and an hour in the afternoon every day. He loves his walks but he knows that whoever holds the lead is in charge.

– *Andriana*

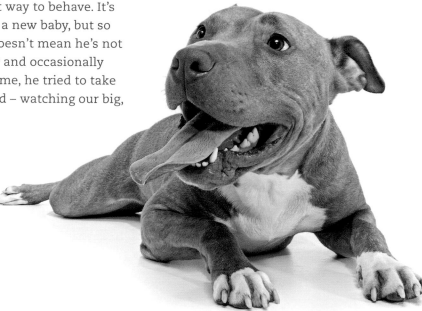

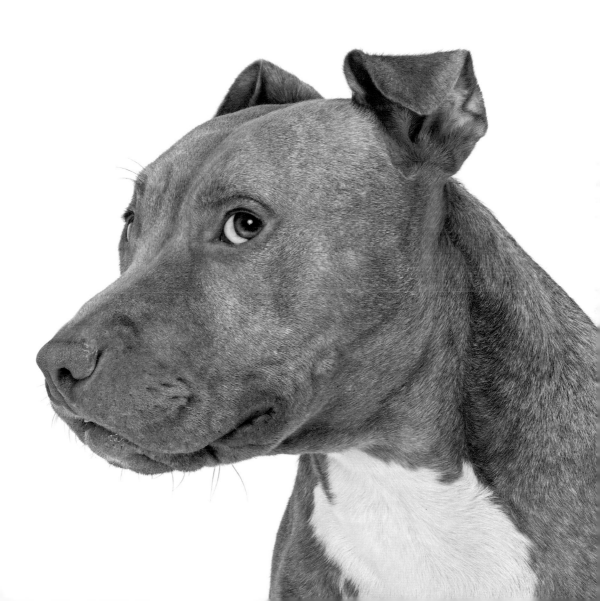

BAILEY

LOST | POMERANIAN | 5 YEARS

THIS FANTASTIC MR FOX LOST HIS TAIL BUT FOUND
HIS FOREVER HOME.

Mr Fox, as he was known, was rescued from a backyard puppy mill. When he came to the Home, he was malnourished and the tip of his tail was a pulpy, bleeding mass. It seemed likely the injury was self-inflicted, a result of distress-induced tail-chasing.

The vet team immediately gave him pain relief to help with the discomfort and monitored him. Sadly, the damage to his tail was so severe that a third of it had become necrotic and it required surgical amputation.

Mr Fox recovered quickly from this surgery but behavioural issues started to emerge post-operatively. Poor Mr Fox was highly anxious and stressed, continuously spinning and squealing. The vet team prescribed medication to treat his anxiety, and he was put into foster care with a staff member who could provide him with a regular routine to help stabilise his behaviour. With careful skill and attention, Mr Fox began to recover, but would still need a forever family who would understand the particular care he needed to overcome his anxiety. Mr Fox was at the Home and in foster care for 99 days before that family finally arrived.

What was your favourite thing to do while staying at Sydney Dogs & Cats Home?

Coming to work and going home with my foster mummy.

How did you rate the cuisine?

Awesome!

Who did you love more – the staff or the volunteers?

I loved them all!

Did you have a favourite staff member or volunteer?

My foster mummy.

How did you choose your new home?

I was sitting in my cage looking really cute, but pretty uninterested. It was a Sunday morning and these people came in to see me. They took me for a walk, and I knew I had them.

What would you say to potential new guests of Sydney Dogs & Cats Home?

They give us warm places to sleep, nice food to eat and the staff and volunteers always have a pat and a cuddle. They are trying to help us find the humans that will give us our-fur-ever home, and will give you loads of love in between. They will also make sure you find a home, even if it takes a long time.

FOUND We've always supported rescuing animals, so when we decided it was time to find a new member of the family, we started searching local shelters and websites. We came across Bailey via the Home's website and we knew we had to go meet the little man.

Bailey has brought a lot of love and laughter into our family. There has been a great deal of rehabilitation and positive reinforcement needed, which has been a great lesson in patience for all of us. In the early days, his little willy was like a weapon of mass destruction! He has peed on carpets, furniture, lounges and the little Buddha who has since been relocated outside the house.

Bailey has some of the strangest traits and behaviours we have ever seen in a dog. He makes us laugh every single day. One of the funniest things he does is try to talk to you when he is angry or excited. He snaps his teeth like a baby alligator and tries to tell you what's on his mind.

He also loves getting into the bin and has a penchant for butter, sweets and, of course, socks.

The joy, love and satisfaction you get from rescuing an animal is endless. People can't believe that Bailey is a rescue dog, nor that he had such a rough start to life. While in the beginning you are doing the rescuing, in the long run these little fur babies rescue you! If you are thinking of getting a pet – please don't shop, adopt!

– *Chantelle*

SPARROW

GREAT DANE-CROSS | 2 YEARS

APPEARANCES CAN BE DECEIVING.

Sparrow was never the prettiest dog, and he had some odd behaviour when he was picked up as a stray and brought into the Home. Estimated to be eight weeks old, the veterinary assessment revealed that Sparrow was deaf and visually impaired, and potentially mentally impaired. Ultimately, Sparrow was diagnosed with a genetic defect as a result of poor breeding. Specifically it is known as double merle, which results in vision and hearing defects in a quarter of the offspring.

Sparrow was put into foster care where he could be further observed and feedback could be provided to the shelter team in regards to his behaviour. Following two foster placements to assess Sparrow's suitability in a home environment, the team concluded that he would need specialist training due to his disability. He was then transferred from the Home to Australian Deaf Dog Rescue, where he thrived and his forever family was waiting.

FOUND My rescue group sent me a picture of Sparrow, asking if I'd be up for fostering a big special-needs puppy who had already

AN INTERVIEW WITH SPARROW

How did you end up at Sydney Dogs & Cats Home?

I was born deaf and with funny eyeballs, so I couldn't hear what I was being told to do. I think no one really knew what to do with me.

What was your favourite thing to do while staying at Sydney Dogs & Cats Home?

Eat.

How did you rate the cuisine?

It must have been good because I had a nice body shape when I arrived at my new home.

Who did you love more – the staff or the volunteers?

The food lady.

Did you have a favourite staff member or volunteer?

The food lady.

How did you choose your new home?

I finally found a person who got me, and I got them.

What would you say to potential new guests of Sydney Dogs & Cats Home?

Hang in there. The right home and family will be there eventually. Sometimes it just takes a little while to get it right.

Do you like sausages from Bunnings?

I love sausages from Bunnings . . . what's Bunnings?

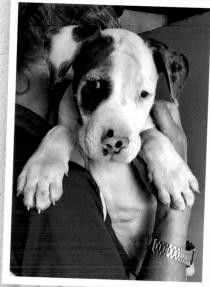

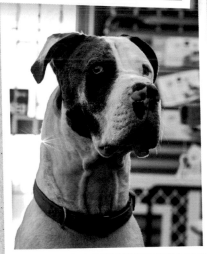

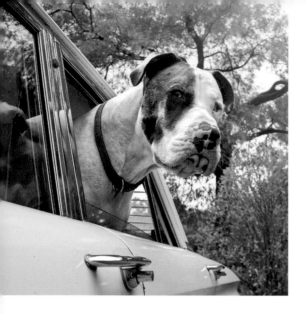

Because Sparrow is touch-trained and is extremely sensitive to touch, I feel he never quite fully relaxes when my husband and I are around him, as we are the training and good manners police. Liam, our youngest son, is definitely Sparrow's favourite. Liam is the fun, cuddly person who can lie next to Sparrow on his bed and Sparrow will fully relax.

Sparrow loves to be involved with everything that you do. Whether you're building a catpole or feeding fish, he'll try to be up that ladder with you or help with tearing boxes open. Though sometimes he gets carried away and chews boxes that aren't meant to be chewed. He also loves to roll in duck poo – always after he has had a bath.

been returned to the shelter twice. My heart melted. When he arrived, it was love at first sight. Fostering turned into adoption and he never left.

This huge goofball makes life worth living. Every day, he makes me laugh and my heart happy. I had just lost my thirteen-year-old Rottie-cross, who was my shadow and my constant companion. I vowed no more big dogs. Then Sparrow arrived; vow broken in no time. Sparrow helped to fill that big, empty gap. I'm just so grateful he fell into our family.

Sparrow's motto is 'I can, I am, I will. Just watch me.' He is an amazing dog who never gives up. He inspires me every day and he has taught me to think outside the box.

– Lex

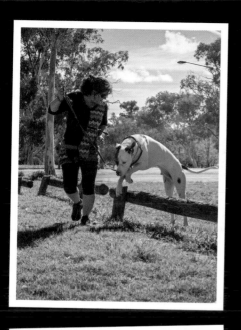

CHARLI

A LITTLE CHARLI LOOKING FOR HER ANGELS.

Charli was a tiny little thing, weighing just 2.6 kg when she arrived at the Home. She had been found roaming the streets in winter with a collar but no tag. It was estimated that she was eleven weeks old, a puppy who was still very new to the world. Sadly, she was not microchipped and nobody came to collect her, but she quickly became a favourite of the volunteers, who loved giving her lots of cuddles and she reciprocated with many excited licks. She was a passionate foodie but had to be taught to sit and wait for her dinner bowl to be put down in front of her as she tended to be a little impatient! Charli's enthusiasm and cuteness meant she didn't have to wait long to find her new family. Four days after her hold period ended, Charli was adopted.

FOUND We had been mourning the loss of our family dog, Ruby, for about a year before we felt ready for another dog to join the family. We always knew we wanted to adopt, so we spent a lot of time looking on the Home's website, and we went there to look for ourselves several times. We applied for another dog but missed out, but then we saw

Charli, so young and cute, and applied to adopt her, though we didn't think we'd be successful. We were so happy when we were.

Having a young dog has been fun, but we'd forgotten how much energy they have and how much training they need! Having Charli has meant we all exercise more and have a lot of fun doing it. We all look forward to coming home after school and work to see her and spend time with her. Charli's favourite game is to steal our belongings and run downstairs with them. She has a preference for stealing bras, shoes and earphones. She prances out to her favourite spot in the backyard, hoping we will chase her. She loves car rides and trips to the beach to chase her ball. She could happily spend all day running around, she has boundless energy.

She loves taking things that she knows she's not supposed to. On Easter morning, Charli jumped onto our daughter's desk chair, climbed onto the desk and stood up on her hind legs to grab her large chocolate Easter egg from the shelf above. She scoffed the whole thing in record time and was found in a nest of tin foil, looking very sheepish. It was a very rapid and expensive visit to the vet to treat the chocolate poisoning! She's also stolen and gnawed on two sets of retainers, which meant two extra visits to the orthodontist, but we wouldn't change her for the world.

– Jo

SASHA

LOST BULL ARAB–STAFFY-CROSS | 9 YEARS

ADOPTING A DOG CAN BE LIFE-CHANGING, FOR ADOPTEE
AND ADOPTER.

This warm, sweet girl was picked up as a stray and arrived at the Home with her pal Tank, a six-and-a-half-year-old Staffy-cross. Unfortunately, due to a change in their owner's circumstances, the pair was surrendered into the care of the Home.

After identifying that Sasha was an anxious dog, the behavioural team tried to rehome Tank and Sasha together. However, while many people were interested in Tank, who was a very friendly fellow, Sasha was a bit of a wallflower and no one expressed interest in adopting her. It's also a rare person who can take on two big boisterous dogs at the same time, so while the team had high hopes, they came to naught.

After two months, the team made the difficult decision to rehome the pair separately. Tank immediately found a home and, not long after, so did Sasha. However, Sasha was returned within a few days as she didn't get along with her new house-mates, a pair of cats. Again, day in and day out, this beautiful old girl waited patiently at the Home, and despite her gentle loving nature, she continued to be overlooked by potential adopters.

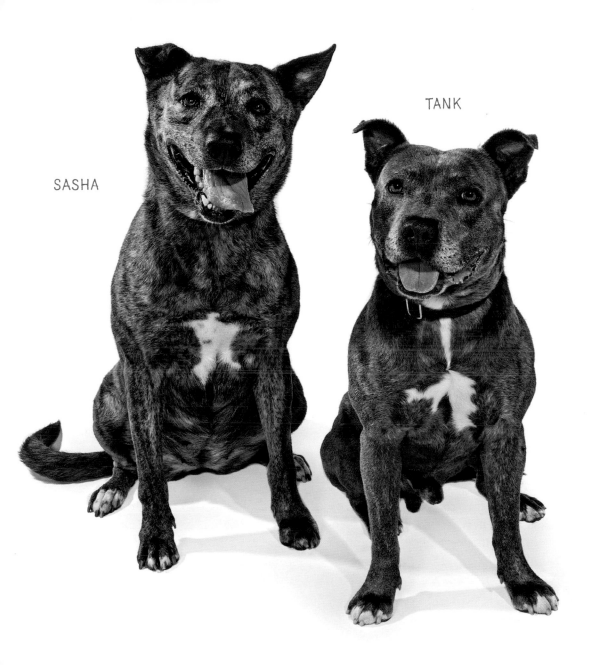

SASHA

TANK

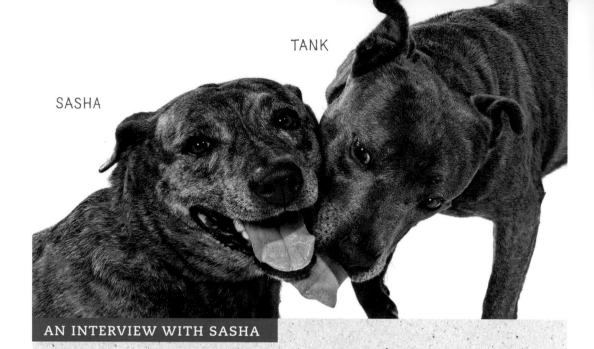

SASHA

TANK

AN INTERVIEW WITH SASHA

How did you end up at Sydney Dogs & Cats Home?

I was found as a stray with my bestest friend, Tank. I was microchipped but my hooman couldn't come back to collect me. So I was put up for adoption. But nobody wanted me, and I was lonely and sad.

What was your favourite thing to do while staying at Sydney Dogs & Cats Home?

The cuddles that the hooman staff gave me where the bestest parts of my day!

Did you have a favourite staff member or volunteer?

Everyone loved me so I loved everyone back.

Who did you love more – the staff or the volunteers?

Anyone who gave me love. I would frequently sit in the office during the day and keep my hooman carers company.

How did you choose your new home?

It was chosen for me and I could not have had a better one. That six months was the bestest of my life.

What would you say to potential new guests of Sydney Dogs & Cats Home?

Don't judge a book by its cover. I was a large, senior dog, but I had a huge heart and a lot of love to give.

To alleviate Sasha's anxiety, she was placed into foster care, where she was spoiled rotten and loved so much by her foster carer that she was adopted, becoming a permanent member of the family.

FOUND The Home contacted me about fostering Sasha after she'd been at the Home for three months. She was feeling lonely and acting very depressed and sluggish. Despite not getting along with other animals, her saving grace was how much she loved human contact and love. The shelter wanted me to foster Sasha to get her out of the shelter environment and into a home where she could flourish.

Having never owned a large dog before, I was initially concerned about how I'd handle her, but I thought I would at least meet Sasha first. When I came to the Home for a meet-and-greet, Sasha just lay there with glazed eyes, like she'd given up hope. My heart broke for her. As I began to caress her, she started to warm up, and then she would push my hand up anytime I stopped patting – she was a snuggle-bug! I just knew this girl had to come back home with me.

Over the following four months, Sasha and I became best friends and inseparable. Sasha's true personality really shone from the moment she lived under my roof, and I was the proud foster mum of a very cheeky, intelligent and loving girl. Despite her age, Sasha showed a young spirit that was so endearing to all those who met her.

I suffer from anxiety and depression and Sasha was my angel. She calmed me down any time I had a bad day or was feeling low. I don't know what I would've done without Sasha there for me. Especially those cuddles I needed in bed. She gave me hope and courage to keep on keeping on with life and just be myself. I'm so glad we could be there for each other.

The Home and I worked tirelessly to find Sasha a family to be adopted by, but no one was showing any

interest. I think most people were put off by the fact she was a senior dog and very large, but I kept thinking, 'If only they could meet her . . .' For those who didn't know much about big dogs, Sasha completely changed their perspective of big dogs because of her warm and loving personality. She was a big baby who just lived life for cuddles and love. I kept wishing that I could adopt her, but I was not in the right situation to adopt yet.

Finally, after four months of nothing, a family showed interest in Sasha! I felt excited for Sasha but my heart broke into tiny pieces. When we went to the Home to meet-and-greet with the other family, I was close to tears. My little angel was going to leave me. When I arrived at the shelter, I sat in the car with my mother and kept saying, 'I can't let her go, I can't let her go.' I suddenly got the not-so-crazy idea that perhaps I could adopt her? I didn't know how it was going to work out with my current lifestyle, but I thought that it

had been working well so far, so why not just keep going? After all, when you find a dog like Sasha, especially with our bond, you will do whatever is needed to be done so that you can be together. So that was it – I made up my mind to adopt Sasha! And I did.

This story had a very happy ending . . . temporarily.

I had a two-month work trip that was planned months before I ever met Sasha, so less than a month after I adopted her, I travelled overseas. I had a wonderful, caring couple to take care of Sasha while I was away, and Sasha was well looked after.

During the first two weeks, Sasha was fine, although I missed her very much. However, during the third week, she suddenly and unexpectedly declined in health. Initially, I thought it was because of stress due to missing me. Then she began acting strange around the couple caring for her; she wasn't eating, didn't want to walk, plus her breathing became shallow and quick. They immediately took her

to the vet, who then directed them to the emergency hospital. My father joined them at the hospital.

I was in Salzburg, Austria, at the time, constantly taking calls from Sydney. I was stressed out and prepared to jump onto the next plane just to be by Sasha's side as her health was deteriorating. At this point, no one knew what was going on, so the vets wanted to do some more tests on Sasha to determine the problem.

It was only an hour after that last call that Sasha suddenly passed away from cardiac arrest while she was under anaesthetic, mid-examination. When I received that phone call, I fell to my knees in the middle of Salzburg and wept. Although I was travelling and exploring this beautiful city, I felt trapped and just wanted to be back home and cradle my baby.

I had never been so sad, angry, hurt and confused in my life. I still had another month to travel before I could come back home and hold Sasha's urn in my arms.

To this day, I grieve her. Sasha meant the world and beyond to me. There is nothing like losing your dog, especially after only spending a month as a proper family. I never got to do all the things I planned to do with her. I wanted to enrich her life, take her exploring, and have the fun she deserved. Still, the short time we had together was the happiest we had both been in a long time. She finally had the family and love she deserved.

I saved her. But really, she saved me.

– *Taylor*

ALFIE

LOST LABRADOODLE | 2 YEARS

SAD STORIES CAN HAVE HAPPY ENDINGS.

When Alfie was just a year and half old, his owners had to move overseas indefinitely to care for a relative who had become ill. They wanted to find the best possible home for Alfie and decided against selling him to some-one they didn't know. So Alfie was sadly surrendered to the Home to find a new family.

Alfie was quite stressed when he arrived at the Home. He didn't know what was happening but recognised that his family were saying good-bye. They were heartbroken to leave him, and in the hours that followed, Alfie kept looking for them to return.

In the end, Alfie's stay was very brief, as he went into a foster home and then was immediately adopted.

FOUND After losing our beloved Labradoodle, Barley, our family was heartbroken. Our home was so quiet, but I felt that I wasn't ready to get another dog. I thought I just needed some time to heal. With so much free time now that we didn't have a pet, I wanted to help some dogs that needed care. So I contacted the Home to become a volunteer. Staff member Sabrina knew I'd lost a Labradoodle not long before, so when

172

What was your favourite thing to do while staying at Sydney Dogs & Cats Home?

I was very lucky. I was only there for one day and one night.

How did you rate the cuisine?

I am a very fussy eater, so I don't think I ate very much at all.

Who did you love more – the staff or the volunteers?

I didn't have a favourite. The staff just tried to calm me down and make me comfortable. The volunteers wanted to pat me, but I was just looking for my family.

How did you choose your new home?

Sabrina knew a volunteer called Cathy who had started volunteering after her Labradoodle had gone to puppy heaven six months before. She was very sad, and thought she wasn't ready for her own dog, but just loved dogs and wanted to help them in some way. Sabrina knew how Cathy loved my breed and called her the afternoon I came into the home. Cathy came and got me the next morning. She couldn't stop crying, she was so happy. Best day ever, she said. For me too.

What would you say to potential new guests of Sydney Dogs & Cats Home?

It is scary, noisy and smelly sometimes, and lots of strange faces walk past you. These faces are the staff and volunteers who are working hard to look after you. Eventually, a strange face stops by and takes you for a walk, and you go home with this new person and start your new life.

Do you know how much you are loved by your new family?

My family has loved me from the minute they took me home. I go everywhere with them; swimming, parks and footy. Mum has lots of friends with dogs, and we go to Queens Park all the time. We have lots of play dates where Mum has coffee and us dogs have treats! Mum says I give the best hugs. They tell me every day that I'm the best and most beautiful dog ever. Who am I to disagree?

Alfie came in, she called to ask if I wanted to foster him. I couldn't get there fast enough and that was that!

Alfie has brought pure joy to our home. He has filled it with all the love and craziness he can give us. He is such a beautiful, playful and gentle dog, but can also be a little devil. We love him completely and he loves us completely.

Alfie has many stuffed toys, most of which have now lost their eyes, nose or ears after he has loved them a lot! When we are going out, he always takes one down the footpath

in his mouth, trotting along. We end up with all of them in the car, so every week, they have to be cleaned out and taken back to the house so he can repeat the process again.

Alfie does have a few quirks; he runs up and barks at little kids on scooters and men riding bikes near parks. He also doesn't like people with backpacks, and will have a good bark just to let them know of his disapproval.

Alfie has a special relationship with all our family members, and each of us would all say we are his favourite, but I'm definitely his favourite at dinnertime!

I can't thank the Home enough for believing that we were the best family for Alfie. We give him the love and attention that he deserves and he gives it back to us tenfold. The best decision I ever made was to volunteer at the Home.

– *Cathy*

BELLA

MALTESE-CROSS | 7 YEARS

THIS BEAUTY BY NATURE WAS TO BECOME A BEAUTY BY NAME.

When the council ranger brought her into the shelter, the dog called Lottie was in a very sorry state. Covered in fleas and with a mouth full of rotting teeth, the team estimated her to be about seven years old. Sadly, Lottie had no identification and no one came forward to claim her.

Lottie was definitely a bad case of neglect and hadn't seen a groomer in a while. Her fur had grown so long it covered her eyes, impairing her vision. Worse, because of the flea infestation, she was suffering from flea allergy dermatitis, which made her skin constantly itchy and caused hair loss on much of her hind legs and back. It was decided that the best way to relieve Lottie's condition was to shave her from the waist down.

Despite being very uncomfortable, after a bath, a haircut and a feed, Lottie's very sweet personality began to shine through. She just needed the right person to offer her a loving home where she would never be neglected again.

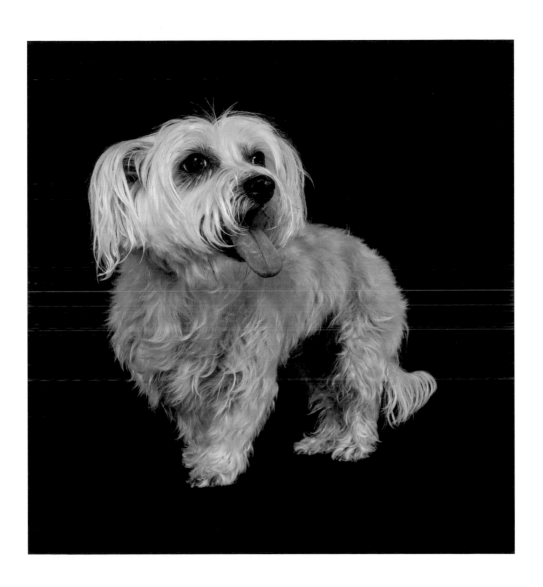

FOUND I was given Bella to take to a puppy cuddle at a corporate office in Darlinghurst for the Home. She sat next to me in the car and she seemed nervous. She was skinny and scruffy, and just not looking her best. I tried to comfort her while we were driving, and she looked at me with such trust that my heart melted.

On the way home, I decided to foster her and see if she was compatible with Lulu and Finn. If it didn't work, then she would at least have a few days away from the shelter and the summer heat. She never went back and I renamed her Bella as I knew she had a beautiful nature and would physically grow into her name.

Bella has become my little shadow; she never leaves my side. She's the first dog I've ever owned and even though I always thought of myself as a cat person, I have now come to realise the loyalty and love that a dog brings into your life is second-to-none.

Her relationship with my cat Finn always makes me smile. Their warm feelings are mutual. They headbutt each other and enjoy being around one another. Finn likes to join us on walks around the block and to the park across from my house. If Finn hasn't joined us for the walk, Bella keeps looking back for him and drags herself along. As soon as he appears, there is a spring in her step. We are quite the celebrities and are often stopped for photographs. I think of them as my own little Milo and Otis!

Bella is a very timid dog and does not respond to strangers well. She is getting better but seems particularly nervous with men and children.

Bella can also be a bit naughty. For instance, she loves to rub the sides of her face in lots of not-so-pleasant things. And at a recent outing to Centennial Park, she found duck poo to be irresistible, coming away with green poo on both cheeks. She looked up at me and I'm sure she was thinking, 'Aren't I clever?' I managed to drive

her home without getting any of it on me or the car, and I put her in the backyard while I got things ready to bathe her. When I opened the door, she raced towards the bedroom and hid under the bed and wouldn't come out! I guess she enjoyed the look?

– *Kerry*

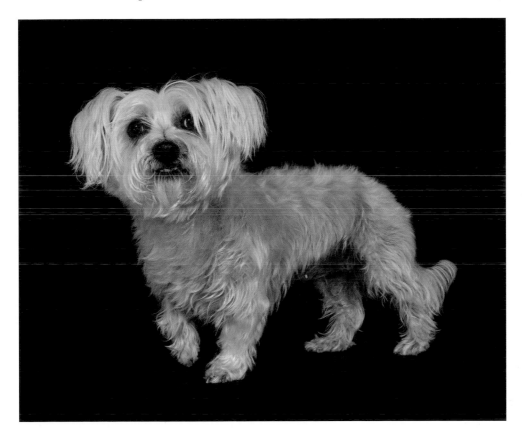

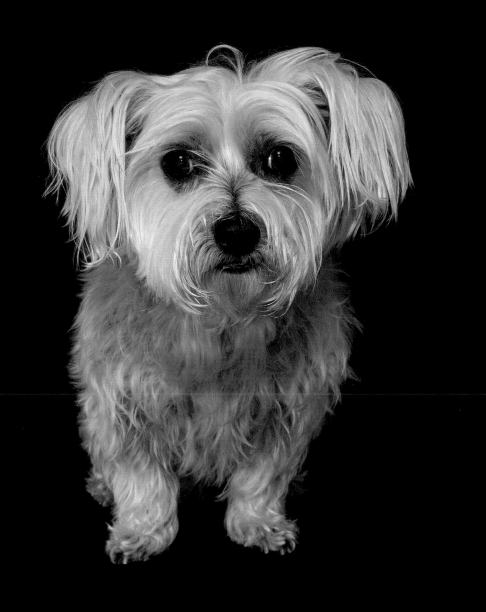

AN INTERVIEW WITH BELLA

How did you end up at Sydney Dogs & Cats Home?

I kind of remember that the people in my previous home weren't very nice to me. I managed to get out and was on my own on the streets for a while. I was very hungry and dirty and had lots of fleas when I was picked up and put in a van. The man in the van drove me to the Home. The people were nice, but I didn't like being in the kennels with all those other dogs barking and making a ruckus. I didn't understand what was going to happen to me. I couldn't go home because my previous owners didn't microchip me or even give me a collar, so I was an orphan. I was very scared.

What was your favourite thing to do while staying at Sydney Dogs & Cats Home?

I didn't get to stay at the Home very long. I was only there for eight days because I got adopted very quickly. I was given a bath, which I normally don't like, but it felt so good and I stopped itching. I liked it when I was given some individual attention and taken for walks and played with too.

How did you rate the cuisine?

I was very hungry when I got there and thought the food was amazing. I'm a fussy eater but they gave me such nice food that I ate it all up.

Who did you love more – the staff or the volunteers?

The staff are great but they are very busy, so I spent more time with the volunteers. I wasn't there long enough to get to know many of them, but they were all really nice to me. Even though I was nervous, I knew they were all very kind and were trying to help me.

Did you have a favourite staff member or volunteer?

My favourite is Kerry, because she took me home with her!

What would you say to potential new guests of Sydney Dogs & Cats Home?

If you are a doggie who gets a little scared in a new environment, then the Home can be a little overwhelming. You just need to know that all the staff and volunteers are there because they love animals and they are working hard to get you back home, but if that doesn't work out then they make sure that you get new loving parents and a fresh start in life, which is really great.

CHILLI

LOST RHODESIAN RIDGEBACK-CROSS | 6 YEARS

PLAYING HIDE-AND-SEEK MEANS YOU'VE GOT TO BE FOUND.

A local council was receiving numerous reports of a large dog roaming around various properties. Every time the ranger went out to catch her, he was evaded, and she would disappear. This continued for months, with a big dog appearing out of nowhere and gathering a following of the neighbourhood dogs. Then, when then the ranger showed up, he would vanish like a frustrating game of hide-and-seek. Finally, the ranger was able to catch up with Chilli and bring her in to the Home.

Chilli was microchipped but when the team called the owner listed on the microchip, they were told that Chilli had been rehomed two years earlier. Unfortunately, the former owner had none of the new owner's details, so the Home could not find Chilli's owner.

FOUND I was looking through the local paper for a companion for our other dog, Clyde. Seeing the picture of Chilli, big eyes staring straight at me, I knew immediately she was the right partner for Clyde. My first thought when I saw Chilli at the Home was that they were showing me the wrong dog. She was

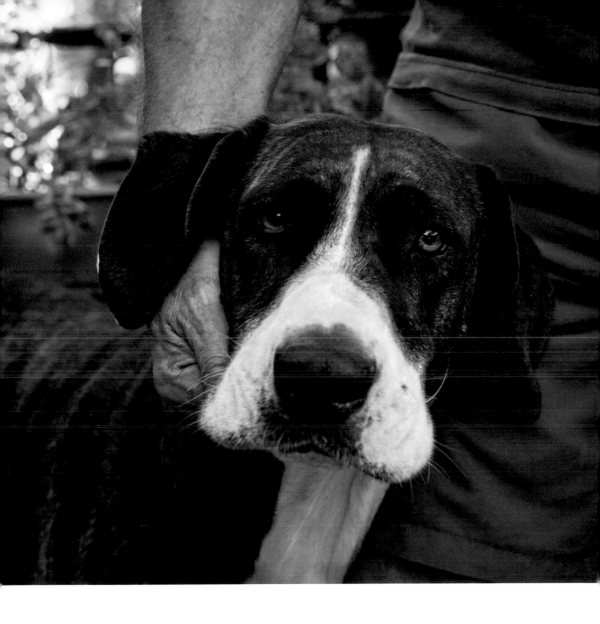

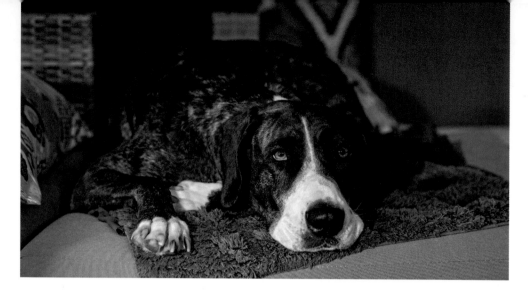

so big! But she and Clyde were like old friends from the moment they met, so she came home with us straightaway. Because we keep our dogs inside, we had to rearrange things a bit. We got new dog beds and made some adjustments on feeding time and other things, but it all went well and was worth it.

Not knowing much about her personality when we brought her home, I carried on as normal the first morning with her. I made some breakfast and went to grab something from the other room. When I came back, all the food was gone. Chilli gave no sign she'd done anything wrong. I got out some bread rolls, went to get the butter and turned back to find the rolls were gone too. Chilli's a hungry girl and doesn't mind whose food it is.

Over the years, we've had all kinds of dogs and each was unique and special to us, but Chilli is different as she is so quiet. Chilli is still a long way off from being a normal dog but she is getting better every day, and she is now starting to wag her tail and show her emotions.

– *John*

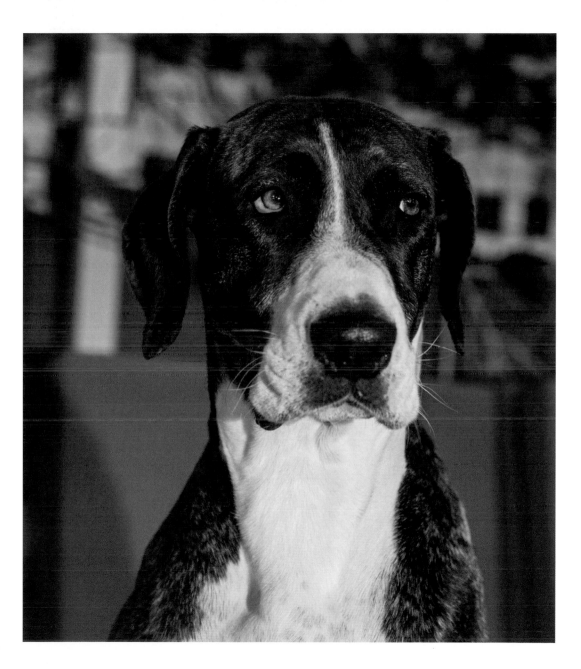

RUSTY

SHAR PEI | 3 YEARS

RUSTY MAY LOOK LIKE HE'S FROWNING BUT HE'S JUST THINKING ABOUT HOW LUCKY HE IS.

Rusty was found wandering the streets alone and with severe eye problems, which caused squinting and weeping of both of his eyes. He was diagnosed with bilateral entropion, a painful breed-related condition in which the eyelids are inverted, causing the eyelashes to constantly rub against and scratch the eyeball. It is a condition that requires early correction and is ideally addressed when a dog is a puppy. Rusty's entropion was so severe that it had left permanent scarring on the cornea. He was in constant pain and his vision was seriously impacted.

With no owner coming forward, Rusty was transferred into the care of the Home. The vet team set a date for a surgery to correct Rusty's condition and alleviate his suffering. As with all surgeries, Rusty was taken to an off-site vet clinic.

Examination of Rusty's eyes under general anaesthesia revealed that he had barely any vision left in his right eye and the scarring to his eye from years of chronic irritation was irreversible. The quick decision was made to remove this painful and useless eye.

Thankfully, his left eye was able to be saved, and corrective surgery was

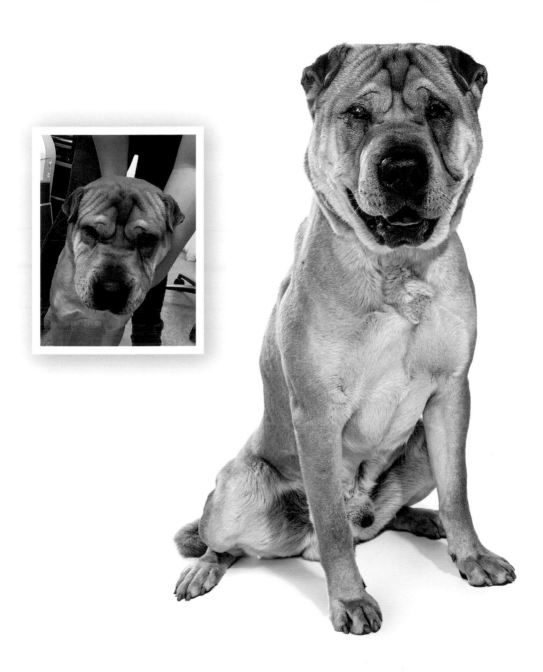

performed to restore comfort and function to the eyelids, and protect his vision. Rusty was then transferred back to the Home to recover.

However, Rusty's troubles were not over. Just when it was thought he had bounced back after surgery, he was put on 'sick report' after refusing food and vomiting. These were concerning signs and taken very seriously. Another trip to the hospital was made to investigate and it was just as well that quick action was taken. Rusty had been suffering from a twisted bowel and part of his intestinal tract had died.

Twenty centimetres of necrotic intestine were removed and then the healthy intestine was stitched back together. The vet team worked on Rusty for three hours in what turned out to be a life-saving procedure.

Thankfully, Rusty recovered from his second procedure and within 24 hours, he was up and about, eating vigorously. Once he recovered, all that was needed to complete his comeback story was the perfect forever home.

FOUND We originally agreed to foster Rusty, but after a few months and no luck with adoptions, we knew he was meant to stay and be part of our family. Rusty gazed into our hearts with his one beautiful eye and we had to give him a chance.

Rusty has settled into the family and home so well. He's even created a perch spot on the kitchen counter so he can watch the comings and goings of the outside world.

Rusty has a bit of a reputation as a food thief. He stole a cobb loaf from a large group of people and gobbled it up before anyone could stop him. There was also the time he jumped off a three-metre cliff for a roast chicken. He ate a lot of sand but he did manage to get the chicken. He was quite proud of himself!

He treats every member of the family as individuals, having favourites for cuddling and other favourites for playing rough. But I think he loves us all.

– *Kristina*

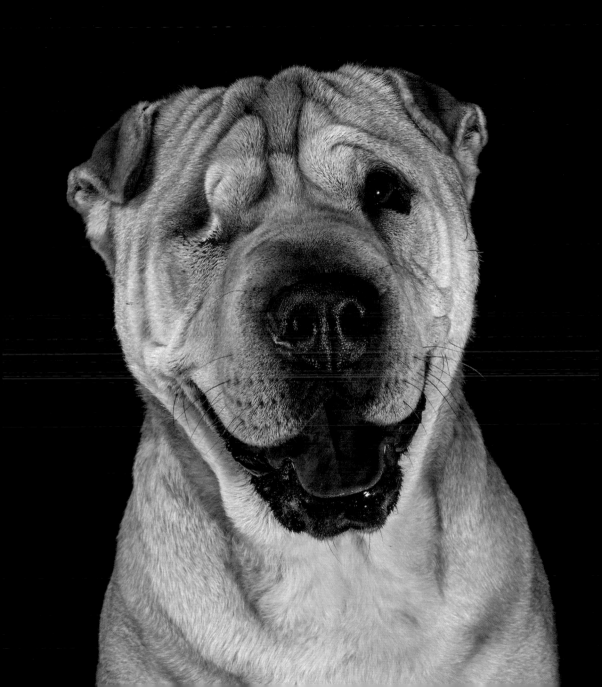

BISCUIT

LOST MINIATURE POODLE-CROSS | 8 YEARS

A DOG WHO FOUND HIS CAT TRIBE.

Gromit, as he was known then, was found by the ranger in the company of a ten-year-old Miniature Poodle-cross that the team named Wallace. Wallace and Gromit had a lot in common; they both needed a good groom to fix their matted coats, they suffered from dental disease and rotten teeth, and they had terrible separation anxiety. Although the two came in together, they didn't enjoy sharing a kennel, so the team knew they were not a bonded pair and could be rehomed separately.

Gromit went into foster care to give him some respite from shelter life. Happily, he was one of the great 'foster fails' and was adopted by his foster parents.

FOUND We had been fostering small dogs from the Home for some time when Biscuit came in. He was struggling at the Home and we decided to give him some respite care in our home . . . and he never left. I think he attached to me like a barnacle when I helped the volunteer groomer clean him up; he picked me for his 'foster fail'.

Our home includes two rescue cats and we were always going to

keep a foster dog who integrated happily with our other fur babies. The cats are now his tribe and the three of them sleep together on the end of the bed.

His separation distress when we first got him was terrible – he would cry, showing signs of stress. A year later and after a lot of training, he is off all medication, very settled and well mannered.

Biscuit has definitely enhanced our lives and lifestyle. Walking him morning and night has put a lot more exercise into our daily routine. He loves to run around with other dogs at Sydney Park, so regular visits there have also become part of our week-end routine. He makes people smile, which has also brought us a lot of joy. Watching him run around with the cats, pinching their toys, trot-ting around the house with squeaky toys or sitting all together waiting for treats is just hilarious. Once he did sample a poo from the kitty-litter box

How did you end up at Sydney Dogs & Cats Home?

The staff at the Home think that I was most likely a backyard breeding dog that had been dumped at the vet when I needed medical attention. I was very scared, anxious and unsure of myself, so I even turned on my buddy that I came in with and ended up on my own.

What was your favourite thing to do while staying at Sydney Dogs & Cats Home?

I didn't love it in the shelter. They put me on some medication to help with my anxiety and eventually, Michelle took me home after I spent some time in a bed under her desk in the office where I felt safe and secure.

How did you rate the cuisine?

In the shelter, I didn't eat much other than moist food until they desexed me and took out ten of my teeth. I felt a lot better after the dental work, but it took a little while to get some confidence about eating solid food from a bowl. Sometimes they gave me poached chicken, which I love.

Who did you love more – the staff or the volunteers?

When I arrived at the shelter, they kept me with my mate until we started to fight with some jealousy issues. At that point, we were still being assessed so were 'staff only' dogs and I didn't get much of a chance to meet the volunteers. The staff were amazing and gave me lots of love. Sometimes, I go back to the shelter to do a community visit to a nursing home or a school for some treats and pats, which I quite enjoy.

What would you say to potential new guests of Sydney Dogs & Cats Home?

Even if you are a shy guy, there is a loving family looking to give you a great new home, so hang in there and the experienced staff will find them for you. Be brave even though it can be scary and show a bit of your potential so they can see what it might like to have you as part of their family. I was a rough diamond waiting to be polished and I am definitely living the good life now in my forever home..

We have often wondered what you and the two cats do all day when we are at work?

You mean you guys aren't at the park when you leave me? Well, first job is to bury my squeaky chicken under the doona in your bed. Next job is to clean up any leftover cat food, check all the doors and windows, and then we pretty much hang out together and sleep all day. Phil and Benson are great company until my humans reappear which is the highlight of my day and warrants a happy dance!

but he never did it again, as it made him a bit sick. Compared to the two cats, he's surprisingly well behaved. He does have a weakness for toys, and the squeakier the better.

The funniest moment since we adopted him was when he fell into the green pond at Sydney Park when he first discovered water; the shock on his face and the green colour when he came out was very funny!

We often wonder what his life was like before living with us. He certainly wasn't in great shape on arrival at the Home but he is now a beautiful little dog. It has taken a few operations to sort out his teeth issues, a lot of training to deal with his separation anxiety and to get him comfortable with being groomed, but it has been very worthwhile.

He loves us unconditionally and is even learning to share lap-time with the cats.

– *Michelle*

PICCOLO

LOST POMERANIAN | 2 YEARS

THE RIGHT COMBINATION OF DOG AND OWNER CAN BRING
A LOT OF JOY TO BOTH.

One day, a two-and-a-half-year-old Pomeranian was picked up and brought to the Home as a stray. Named by the team as Herc, no one came forward to reclaim this adorable fellow. While he was healthy and had been well cared for, he wasn't micro-chipped so there was no way to track down his family.

Herc spent a total of eight weeks in the care of the Home. During that period, he spent a lot of time as the office dog where his peculiar habit quickly developed: he loved jumping up on the office chairs, then onto the desk and ultimately, he would curl up on a keyboard and settle in. This bizarrely adorable behaviour earned him the nickname Cat Dog. Herc just didn't like to be on the ground – he wanted to be up high, like a cat.

Super affectionate and cuddly, Herc loved to be around people. This also meant he suffered from separation anxiety when left alone, so he would cry out and become distressed. It would take someone with a lot of love and attention to take him home.

FOUND One of my dog-walking friends took Piccolo home from the Home on a trial basis.

My friend had two other dogs and they did not warm to Piccolo, so it was a love-at-first-sight decision for me when my friend asked if I knew anyone who would take him. It was hard to say no, and the rest is history!

Piccolo has brought me lots of happiness and humour. His chemistry with my other dog, Roxie, has been wonderful. It was a little bit of a rocky start with Roxie as Piccolo liked to steal her favourite squeaky toy, run away and pull it apart. They took a little time to adjust but it has certainly helped now that I've made sure he has plenty of his own toys to keep him happy.

Piccolo has made me realise how important a dog can be in making people happy. He has been so much fun and he keeps making me laugh, like when he establishes little kennels around the house. He surprises me every time I find him comfortably at home in a nook or a cranny, perfectly content under a stool or a coffee table or in some otherwise obscure corner of the house that he's decided is his special space.

He is a bundle of joy, but you can see in his eyes he's had some hard times. Thankfully, he's getting better every day and that is a delight to see.

– Jane

DJANGO

LOST MALTESE-CROSS | 8 YEARS

HEAD + HEART = PERFECT PAIRING

Known as Tango on his arrival at the Home, his was a terrible case of neglect. He had alopecia, probably as a result of flea allergy dermatitis, which had resulted in extensive hair loss on his tail, hind legs and back. His nails were severely over-grown and he had terrible dental disease, including severe tartar build-up and periodontal disease, which caused him a lot of pain. Although he was desexed, Tango was not microchipped, and no one came forward to claim this dear old soul.

His teeth were in such poor condition that the team immediately provided pain relief and organised for Tango to have an emergency dental surgery, which led to the extraction of multiple teeth, after which he felt much better.

A staff favourite, Tango spent his days behind the reception desk until he was adopted. Thankfully, after only eleven days, the right person came along.

FOUND Getting a dog requires commitment, no matter what. Even the best thought-out plans go off track but if we all take the time to assess our situations and

be patient when choosing, then it is likely that fewer dogs would end up in the shelters.

I work as a dog trainer with many dogs, so I wanted to choose carefully and set a good example. When I was looking for my boy, I thought it best to be honest with myself about what I truly wanted and what wouldn't suit my lifestyle. Bringing a dog into my life was a big decision that I wanted to get right for both myself and them.

While I love big dogs, I rent, so a small dog made much more sense, as who knows when I may have to move again and get the little man accepted into a new place to rent. At the time, I also lived with a cat, and so I was looking for a dog that had to be cat-friendly.

I love to exercise, but when I thought about it, this was something I loved to do for me and was my alone time. I did not actually need a high energy dog who was going to be my exercise buddy. I also prefer taking my dogs to places to relax with them, such as quiet walks, picnics, cafes and pubs rather than dog parks, so this made me realise I probably need a dog that likes to chill out with me rather than run around endlessly.

Because I work with dogs, it was also important to me that my new buddy had a rock-solid temperament and was friendly with people, children, dogs and other animals. While I work from home some days, there are also days that I'm out the house for long hours, so a dog that could settle at home unsupervised was very important.

I also had to listen to my heart, which was telling me to get a male dog, one that was scruffy and older because I wanted to give an old man a second chance.

I looked on the website daily for months. I knew that bringing this guy into my life was a commitment, and while some of the dogs I saw were brilliant dogs, they were not Django. I am so glad I was patient.

Django just makes my life better. He's a dog with a very calm nature who doesn't want to go for big runs and loves to settle in calm places. Being an active person, he keeps me grounded, reminds me when to stop to smell the roses and to just enjoy the simple things in life.

Django is a goose. Not a day goes by in which he doesn't make someone laugh. He's clumsy, a little bit dopey and we're pretty sure he never read the manual on how to be a normal dog. Django's funniest moment was when we were at our local cafe and he fell asleep and then started to dream, probably about the bacon he'd just been given. He started to run in his dream and got quite animated, when he suddenly kicked himself off the back wall and straight off the bench. He woke up with a shock, looking around to see what had happened, but then went back to sleep on the floor where he landed! Nothing much bothers Django.

It's been such a breeze bringing him into my life, and while he's transformed from the scruffy fella I thought I was getting into a fluffy gent, we could not be happier.

– Ian

204

AN INTERVIEW WITH DJANGO

How did you end up at Sydney Dogs & Cats Home?

Who knows? One minute I'm walking along the streets and then next minute, I get picked up. Don't get me wrong, I'm glad they did, they took such good care of me, but that part of my life is a bit of a blur.

What was your favourite thing to do while staying at Sydney Dogs & Cats Home?

It was the first time in a while that I got to sleep in a bed and get some love from people. It's the simple pleasures in life that we can often take for granted that I had really missed.

How did you rate the cuisine?

Well, what can I say? Two meals a day! I felt like royalty compared to the slim pickings on the street. Meals fit for a king.

Who did you love more – the staff or the volunteers?

Am I allowed to pick favourites? The volunteers took me out for walks, and I do love a walk. But the staff took me into the office and fed me so many treats. So if

I had to pick a favourite . . . I pick treats, I mean staff.

Did you have a favourite staff member or volunteer?

Treats?

How did you choose your new home?

It was an instant bromance. I knew this guy was going to be my best mate and was never going to leave me.

What would you say to potential new guests of Sydney Dogs & Cats Home?

When you get there, while it might be a bit confusing, don't worry. This is the beginning of a new better life. Everyone you meet is there to love and care for you. They'll take their time when you need it, run and play with you when you want it and feed you all of your favourites.

What on earth was happening in your life before we met?

Who knows, buddy? I don't even know what day of the week it is. You got any treats?

JESSIE

KELPIE-CROSS | 2 MONTHS

FIVE LITTLE KELPIE-CROSS PUPPIES WERE FOUND
ABANDONED IN A PLASTIC STORAGE CRATE.

Jessie was one of these dear little pups. The team estimated they were about eight weeks old, and they each weighed less than two kilograms. As soon as they arrived, all of the puppies, including Jessie, were put into foster homes. It's the Home's policy that puppies be immediately placed in foster homes. This is both for quarantine protection and to support the development of good behavioural and socialisation skills.

Within a month, the team at the Home had been able to find all the puppies, including Jessie, new forever homes.

FOUND We had been visiting the Home on and off for about a year just 'looking'. When Jess was produced for us to look at, we both thought she was the most adorable thing ever. Strangely, my husband thought I really wanted to get her, and I thought he really wanted to get her. Twenty minutes later, we walked out with a twelve-week-old puppy!

We are a blended family and chose not to have more children together. Getting Jessie was really the icing on the cake for our little family. I think one of the most amusing things is that Kelpies are supposed to be super high

AN INTERVIEW WITH JESSIE

What would you say to potential new guests of Sydney Dogs & Cats Home?

Don't be too scared. It's hard not to bark when you are very scared and just want to go home. Someone will come soon and take you home to love you just the way you deserve.

How did you rate the cuisine?

Five stars! But then, I eat just about anything.

How did you choose your new home?

I thought that this couple should have another baby, but maybe not a human baby. I thought I could satisfy Mum's maternal instinct. I think I'm a bit easier than a human baby too!

What breed were your parents, Jess? You look like a Kelpie, but you act like a ragdoll cat!

Who knows?! All I know is that I have the best parents ever who love me and kiss me and fuss over me all day long.

energy but Jess will literally sleep all day. We joke that she is the laziest Kelpie in Sydney.

Little did we know our family was soon going to grow by one more. The Home asked us if we'd be interested in fostering. We agreed and along came Tilly, your typical crazy Kelpie. High energy, very clever and so loyal.

Jess and Tilly bonded our family even more so we decided to adopt Tilly as well! Our three kids adore them both. We often find the dogs in one of the kids' room when the kids are a bit sad about something. Animals are definitely therapeutic.

Jess has a very special bond with my daughter, Annika. When we can't find Jess, she is often resting with her head on Annika's lap.

Tilly also has a funny relationship with one of the cats. They adore each other, often rubbing up against each other. Jess is the cool, calm older sister to Tilly's super excited personality. They are perfect with each other.

– Alison

TILLY

JESSIE

BENEFITS OF ADOPTING

There are numerous benefits to adopting a dog – mental, emotional and physical. When the shelter rehome a dog, they try to match the potential owners' needs with that of the dog. Some of the benefits for humans include:

MENTAL

They are always happy to see you come home.

Studies show that human stress significantly decreases after interactions with animals. Petting an animal can increase levels of oxytocin (stress reducing hormone) and decrease cortisol (stress hormone). Dogs and cats in particular can reduce stress, anxiety and depression, ease loneliness and also encourage exercise and socialisation.

They create a routine for their owner – walks at same time, meals at same time etc. – and create a sense of purpose: you have a life that is totally dependent on you for care – food, shelter, physical and mental stimulation, and vet care.

EMOTIONAL

They provide unconditional love, affection and companionship, with no strings attached.

They make great listeners and never judge.

They are great ice-breakers and can help their owners expand their network, meet other people in the community with dogs or have conversations with perfect strangers who want to pat your dog.

PHYSICAL

They increase your exercise and daily walks with your dog can improve your health. Most people who adopt a dog experience a significant increase in their own physical activity.

ADVICE FOR LEAVING YOUR DOG IN SOMEONE ELSE'S CARE

To help safeguard your pets should you leave them in someone else's care, we have developed the following precautionary checklist:

Make sure your pet is microchipped, the contact details are up-to-date and the animal is registered with the relevant government authority. As each state and territory has a slightly different registration process you will need to comply with your local regulations.

Add the carer or a trusted friend who isn't on holiday with you as a 'secondary contact' on the microchip.

Ensure your animal has a collar with a tag, which features your contact details and those of the temporary minder. Do it yourself; don't rely on the carer to add their details.

Leave the carer with the number of your local impound facility as well as the contact details of your local vet.

ADDITIONAL ADVICE

Double-check the carer's fencing to ensure it is secure with no means to escape.

Brief the carer to leave the dog's collar on at all times.

Advise the carer to only ever walk your dog on lead – even at the off-leash dog park.

Ask the carer to stick to your routine as closely as possible (e.g. feeding times and walking, etc.).

ABOUT PETER SHARP

Peter Sharp is an award-winning photographer, specialising in studio pet photography.

Peter has been passionate about photography since his grandfather gave him his first camera at age thirteen. Since then, he has tried his hand at different types of photography, including a highly successful stint in the music industry.

Come 2015, he wanted to seek out something more, something he could believe in and be passionate about.

While on a trip to Africa that summer, he realised that his lifelong love of animals could become that something more.

The combination of his passions – photography, music and animals – came together in February 2017, when he opened Tame & Wild Studio, a studio designed solely for photographing pets and animals.

Since its inception, Tame & Wild Studio has been recognised both nationally and internationally, receiving more than 70 awards in Australia, New Zealand, Japan, the UK and the US. Peter was also awarded the 2018 NSW Pet/Animal Photographer of the Year and was a finalist in the 2018 Australian Photography Awards in the same category.

From day one, Peter looked to give back to the community. So since 2017, he has spent a day a week at the Home, taking photos of the animals looking for new homes. These include not just dogs but also cats, rabbits, chickens, roosters, guinea pigs, birds and even mice.

Many people who adopt state that their first impression of their new pet, through the photo online, was crucial in their decision. So Peter really is a human–animal matchmaker! Mindful of the important role photography can play in uniting dogs

with the right family, Peter takes this responsibility and honour very seriously. His love for and nurturing of the animals is palpable in the stunning portraits he creates. In 2019, Peter was humbled to be formally made an Ambassador for the Home.

ABOUT SYDNEY DOGS & CATS HOME

The Home is Sydney's only charity pound and community facility. Servicing multiple councils across Sydney, they take care of some 3000 lost, abandoned and neglected pets each year. If they are unable to reunite a pet with its owner, they seek to find them a new and loving home.

The Home has the capacity to look after 33 dogs and 33 cats. In addition to this, it has an extensive network of foster carers who take animals temporarily into care if they are not coping with the shelter life or if the shelter is at capacity. This network increases the Home's ability to care for and provide shelter to more than 100 additional animals.

The Home does not receive government funding for their work rehoming the abandoned pets, and does its incredible work funded by community donations and the support of Hill's™ Pet Nutrition.

In 2011, the Home became the first council animal holding facility in NSW to become a member of the Getting 2 Zero (G2Z) movement, which aims to achieve zero euthanasia of all healthy and treatable cats and dogs. The Home has a strict no-time-limit policy on every animal awaiting adoption.

More than 500 volunteers give over 18,000 hours of their time each year to the Home. Volunteers help in a myriad of ways, from cleaning kennels, walking dogs and doing laundry, to supporting the reception team by answering phone calls, updating records and completing other paperwork. The Home also has volunteer transporters to transfer animals from the shelter to adoption partners, and to foster carers. Volunteers can also help at public events promoting the work of the Home.

The Home has an extensive

network of foster carers, who can take animals temporarily into care if they are not coping with the shelter life, or if the Home is at capacity. This network increases the capacity to care, enabling the Home to look after even more animals than can be held at the facility.

The mission of the Home is to find homes, whether by reuniting pets with frantic owners or finding the perfect placement for an abandoned animal. They believe everybody needs a home – a place where you can truly be yourself and feel safe and loved. If you'd like to find out more about adopting or fostering an animal, please see the Home's website: sydneydogsandcatshome.org.

ACKNOWLEDGEMENTS

Thank you to my amazing wife Nicola – the work I do would not be possible without your support. I owe a huge thank you to my family and friends for your love and support over many years, many projects and many challenges. In particular to Mum and Dad, Sara and Ron, the wider Sharp and Molloy families, and my two closest friends, Dylan and Simon.

To Faith, who without her passion, energy and the hours of work behind the scenes, this book would not have been possible. I am forever in your debt and grateful for your friendship.

From the time I started volunteering at the Home, I have been fortunate to meet and work with some of the most dedicated and inspirational people who work tirelessly for a cause they wholeheartedly believe in. These include Stuart, Amanda, Jennifer, Renae, Sabrina, Michelle, Sue, Alanna, Siobhan, Hannah, Katharine, Sofi and Felicia. Special mention must go to those who volunteer to help me each week – Daniella, John, Karen and Nyssa – your time and efforts are very much appreciated. Thank you also to Melissa for willingly sharing your expertise about the mental-health benefits of adopting rescue animals.

I owe a great deal of gratitude to the team at Pan Macmillan who have helped bring this book to life. Thank you, Angus, for understanding my vision for this book, and for your instrumental role in propelling this project forward. Thank you, Danielle, for your patience and enthusiasm as we pulled all aspects of the book together. Thank you, Libby, for collating the stories in the book. Thank you, Mark, for your expertise in designing the layout of the book. Thank you, Ingrid and Naomi, for your support of this project.

Last but definitely not least, my immense thanks and gratitude is extended to all of the dogs and owners who have generously shared their time and stories with me.